The Absolute Beginner's Guide to

TAKING GREAT PHOTOS

Jim Miotke

D1364513

PRIMA PUBLISHING

Published by Prima Publishing, Roseville, California. Member of the Crown Publishing Group, a division of Random House, Inc.

PRIMA PUBLISHING and colophon are trademarks of Random House, Inc., registered with the United States Patent and Trademark Office.

All products and organizations mentioned in this book are the trademarks of their respective companies.

Interior design by Susan Sugnet, Prima Design Team.

Unless noted otherwise, all photos taken by Jim Miotke.

Library of Congress Cataloging-in-Publication Data

Miotke, Jim
 The absolute beginner's guide to taking great photos / Jim Miotke.
 p. cm.
 Includes index.
 ISBN 0-7615-3604-3
 1. Photography—Amateurs' manuals. I. Title.
 TR146 .M56 2001 2001052074
 771—dc21

02 03 04 05 HH 10 9 8 7 6 5 4 3 2 1
First Edition

Visit us online at www.primapublishing.com

To my wife and best friend, Denise

Contents

Acknowledgments

I would like to thank my wife, Denise, for encouraging me, helping me edit, and allowing me to use many of her best pictures (Team Miotke!).

My gratitude also goes out to Maggi Foerster, who has been an inspiration and a supportive friend throughout the writing of this book.

I would also like to thank my parents—Jack, Mary, Brian, and Marti—for their years of support and encouragement, as well as their patience as I made them sit through hours of slide shows and be my first focus group.

I thank Chris Groenhout for the use of his photos to illustrate the developing process, and Frank Weinstein for the generous loan of his scanner.

And I deeply thank Libby Larson, Denise Sternad, Linda Weidemann, and Ruth Younger for helping me make this book much better than if I had tried to do it on my own; Lorna Eby for contacting me in the first place; and everyone at Prima Publishing who have helped make this book a success.

Introduction

Hi, there. My name is Jim Miotke, and I'm here to help you out with your pictures.

Believe it or not, photography does not have to be difficult. You can easily get to a point where you're taking great pictures all the time.

People have a funny attitude about taking pictures. On one hand, most people think photography is so easy that anybody can do it. On the other hand, when a few bad photos come back from the photo-finishing lab, we call ourselves bad photographers.

Can you press a button? Then you can take great pictures. It's as simple as that. All you need to know are the simple guidelines and tips you will find throughout this book.

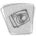 ## LET ME PAINT YOU A PICTURE

Here's the scoop on taking pictures: You won't find an easier, more enjoyable hobby with as many ways to creatively express yourself and continually grow in your understanding of the art.

You may have noticed the current interest in digital imaging and scrapbooking. As far as hobbies go, these two areas

of artistic endeavor are hot tickets—for good reason. They offer many ways to visually express yourself. What's more, they serve a practical purpose, allowing you to record details of your life. You need not join the digital and scrapbooking bandwagons, though, in order to visually express yourself; people discover their love of photography following a multitude of paths and interests.

> *People think that all cameramen do is point the camera at things, but it's a heck of a lot more complicated than that!*
>
> —Larry, in
> *Groundhog Day.*

We take pictures so we can put them in an album, frame them and hang them on the wall, or e-mail them to friends and family. Sometimes, we get the urge to enter a photo contest, make our own photo postcards, or even photograph a friend's wedding. For the most part, though, we take pictures to help us remember our most special moments.

Whatever your photographic goals, this book will show you the easy path to achieving them.

WHAT THIS BOOK OFFERS

Photography is not rocket science. Anybody can enjoy it. At the same time, learning photography *can* be scientific. That is, through systematic study and practice, you can gain the skill to repeatedly obtain the kind of results you want.

If your attempts to learn photography have been disappointing, it's time to try something different. That's where this book comes in. Let's take a quick look at what you'll be learning.

A Short and Sweet Introduction to the Art

One of my top goals when writing this book was to keep it from putting readers to sleep. Therefore, don't expect a typ-

ical, comprehensive, and boring photography textbook. If you want a big, thick textbook on photography, you can find a number of them at your local library; just be prepared to spend hours sifting through details. This book, on the other hand, is meant to be fun—a truly enjoyable way to learn with your camera. Take this as your "CliffNotes" version to getting started in the hobby. Instead of spending months straining your eyes over a series of textbooks, this book will have you out taking better pictures before you know it.

> *"What is the use of a book,"*
> *thought Alice,*
> *"without pictures. . . ."*
> —Lewis Carroll, from
> *Alice in Wonderland*

Photography for Non-Math Majors

I'll be honest with you: I know practically nothing about math. I failed my high school trigonometry class (don't worry, I'm doing just fine without it). All the same, I am happy to report that little if any math is required for one to become a great photographer. Although advanced photographers often enjoy calculating light values and exposure times, you can easily avoid investing time in these issues if you so choose. Being able to multiply and divide is helpful, but you need not be a mathematical genius.

A Practical System That Has Been Proven to Work

This book is filled with rules and guidelines derived from years of practice. They are intended to quickly get you going with your own unique, creative photographic expression. You can always make exceptions to the rules, but you need to at least understand what the rules are and why they are generally considered good guidelines.

In addition to these basic rules, I've included many tricks of the trade that only more experienced photographers usually know about. These secrets will help you cut corners,

save even more time, and enable you to get interesting, artistic, and pleasing pictures time after time.

A Plethora of Inspiring Assignments and Helpful Answers

This book will help you put concepts and guidelines into practice. Chapter 5, "Putting It into Practice: 20 Step-by-Step Projects," will give you a number of photo assignments to hone your craft. This book will also speed you through the tough parts by giving you easy ways to solve your most challenging problems. Chapter 6, "Troubleshooting: Solutions to Common Photo Problems," helps correct specific mistakes by showing a picture problem and then explaining exactly how you can solve or avoid it on future shoots. To keep you from getting unnecessarily stumped, the questions and answers in chapter 8 offer helpful solutions to problems that puzzle most beginners.

This book effectively teaches by making photography easy and fun. All the same, we do have a few rules around here:

- There are no dumb questions.
- Photo-snobbery is not allowed. People are not to be judged by the gear in their camera bag. Teasing others because they don't have an expensive camera is strictly against the rules.
- Overly technical explanations have been banished. You will find only the simple truths that will help you the most. By following the guidelines in this book, you will learn more efficiently than through plain old trial and error.

 ## EVERYBODY'S INVITED TO THIS PARTY

I make no assumptions about you or your skill level. For those who are totally new to the hobby, I start from the absolute beginning, showing you how to point, shoot, and have fun.

If you have already been shooting a bit, you are probably reading this book because you are frustrated with unsatisfying results when you pick up your developed photos. You have come to the right place; here you'll find the tools you need to consistently create better photos.

Regardless of your skill level, the most challenging topics can suddenly become simple when explained properly. Even more advanced photographers will find new tips and tricks in this book.

Regardless of your skill level, you have what it takes right now to shoot fantastic pictures of your kids playing soccer, your wife winning a tennis tournament, or your husband holding his six-ounce trout with pride. You are, in fact, already well on your way to becoming an amazing photographer.

Why You Are Here

You may be planning a trip and hoping to bring back better-than-average pictures. On the other hand, you might be reading this *after* a trip—and after you realized that, despite the promises and slogans you read in camera advertisements, you had a hard time getting good shots.

Perhaps you are interested in getting better photos of your kids. Maybe your boss is asking that you learn to operate a new camera so you can take pictures of products and upload them to the company Web site. Or perhaps you are the designated family photographer, in charge of snapping pictures of the grandkids on Christmas morning while the other grown-ups blink the sleep out of their eyes.

Or maybe you feel that nothing is left out there to photograph, when in fact, you are presented with photo-worthy sights every day—perhaps a neighbor's new puppy, a beautiful blooming flower, or a sunset that knocks your socks off. Photographing them accurately or artistically, however, is often a different story. Often, the prints you get back from the photo lab don't do justice to the magic and beauty you witnessed at the scene. Your sunset print is small and dull. Your flower is a blurry blob of color, without any definition.

The only part of the puppy in your picture is his wagging tail. But, trust me, it doesn't have to be this way. You can turn around your photographic efforts and get more and more great pictures.

The Camera You Own

I imagine you already own a camera, though it may not be the latest and most expensive model. You can get shooting right away with whatever camera you have at hand. As you take your first steps, at least, it matters little whether you use a simple point and shoot, a Polaroid instant camera, a digital camera, a 35mm SLR, or a $10 disposable. You can learn with whatever camera you have. If it has been buried in a shoebox in the back of the closet for the past few years, simply dust it off, put in a fresh battery and a new roll of film, and get ready to shoot. If you are in the market for a new camera, a slightly more expensive SLR camera may take you far into your photographic hobby. You'll find more on purchasing cameras and gear in chapter 2, "Buyer's Guide."

The camera you use is only one of many factors that determine the quality of your photos. The control you have over getting great pictures will become more apparent as you master the skills and principles covered in the chapters that follow.

You're Not Alone

Perhaps you already tried to read a book or two and still felt stuck in the mud. If you have been through a slough of boring textbooks or endured your share of technical photography classes, and you still feel lost, know that you aren't alone. *Everybody* has questions about how to make better photographs, and most people think of themselves as bad photographers—often because they unconsciously accept myths that surround photography. Mired in uncertainty, many never get beyond the first step because they are simply too embarrassed to ask basic questions. If you've been

feeling lost or helplessly subjected to the whims of your camera, this book will show you how to regain control.

THIS IS WHERE I COME INTO THE PICTURE

I have been into photography since I was a wee little one. As a kid, I used disc cameras, 110 Instamatics, and other point and shoots for fun snapshots—nothing too artsy. In fact, few of the early photos I took of my friends included their heads. Still, I am grateful for these childhood mementos and the fun I had making them.

About fifteen years ago, I bought my first professional camera and began seriously exploring the art of photography. I took classes, went to workshops, and studied as many photography books as I could. Most importantly, I took as many pictures as possible and carefully analyzed the results. Before I knew what was happening, I found myself running my own business, specializing in wedding photography and portraiture. I was soon selling stock photography and writing articles that focus on photographic technique.

In the spring of 1996, I began BetterPhoto.com—a free Web site that teaches visitors how to take better pictures. The site features articles on how to improve technique, up-to-date assistance with selecting equipment, photo galleries, a photo contest, and help with all aspects of beginning photography. Since it was launched, BetterPhoto's mission has been to provide honest answers to budding photographers around the globe.

For some time, I had been leaving little Post-it notes all around the house (much to my wife's chagrin) about an introductory guidebook dedicated to first-time photographers. When the editors at Prima Publishing asked me to work with them on just such a project, I was delighted. The book you now hold is the result, and I am thrilled to be helping you find answers you need to become a better photographer.

My Friends Made Me Say This

Although the title of this book suggests otherwise, true photographers do not "take" photos, they "make" photos. Many photographers I know seem to get bent out of shape when they hear talk about "taking" great pictures. It is true that one does not casually grab pictures from the environment with the aid of an all-powerful super camera. *Making* photos is much more creatively rewarding than *taking* snapshots. All the same, had we titled this book the *Absolute Beginner's Guide to Making Great Photographic Expressions Blah De Blah De Blah,* you might have been less inclined to buy it (and we wouldn't want that to happen!).

> *You don't take a photograph, you make it.*
>
> —Ansel Adams

So let nothing get in your way. Your days of photographic frustration will soon be over. When you share your photos, you'll no longer need to explain each picture ("That little dot in the corner is Aunt Margie") and you'll no longer need excuses for your photo mishaps. Regardless of the camera you use, your level of experience, or your artistic creativity, you have what it takes to make great pictures.

To begin this exciting journey, let's explore what photography is really about. In chapter 1, I share my take on the many pleasures (and occasional pitfalls) the hobby of photography offers. So in the time it takes to say "cheese," let's start learning how to make better photos.

Photography:
A Snapshot of the Art

Photography can be as fulfilling or as painful as you make it. Although many past masters and countless struggling students have suffered their way through the art, your interpretation of photography need not be so laborious. While learning your new hobby, your path can be easy and satisfying, or it can be strewn with difficulties. This chapter describes the various aspects of photography so you will be able to see the best path, the one that allows you to take it easy while taking pictures.

We begin by exploring a detailed description of what the photographic art is really all about. We will blow apart the top ten myths about picture taking and examine the true pleasures and occasional pitfalls to be found in the hobby.

Then we will take a peek at the infinite array of subjects from which you can choose. Whether you like to photograph the places you visit, your children, your pets, or something else, deciding which subjects you most enjoy shooting will play a big part in determining what photography means to you.

> *Photography is 90% sheer, brutal drudgery!*
> —Brett Weston, photographer

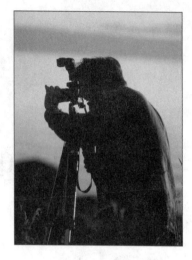

Finally, we will look at a photographer's main tools—camera, film, and flash—and try to figure out how they work. Fear not; we won't be taking any cameras apart. Rather, we will

Figure 1.1 Photographer silhouette. Photo by Denise Miotke

use a simple metaphor to explore the main principles behind the equipment. Once you understand how these tools work, you will find mastering the tips and techniques you'll encounter later in the book much easier.

BARE BONES DEFINITION OF PHOTOGRAPHY

We've all heard the word photography, but many of us do not have a clear idea of what practicing the art of photography is actually like.

> *There is nothing either good or bad, but thinking makes it so.*
> —William Shakespeare

What Photography Is

Photography is a system—initiated by the exposure of an optical image on photosensitive elements in the emulsion of a plastic material called film and culminating in a rendering of said optical image on a photosensitive substrate such as paper—that utilizes sophisticated camera technology, carefully crafted

lenses, and a competent (dare I say, masterful?) understanding of chemistry. Blah, blah, blah.

While this may *describe* something of the technical side of photography, it doesn't tell us what photography is all about.

Photography is not confined to the technical details. It is about life—capturing the look of exhilaration on your daughter's face as she opens a birthday present or masters the art of riding a bicycle for the very first time. It's seen in the adorable snapshot of your kitty that's taped to your refrigerator door.

True photography can be seen in the way you catch the light coming through the trees while hiking in the mountains. It is apparent when you are able to do justice to the beautiful array of colors in the roses or tulips blooming in your garden.

Photographs hint at the magic of being able to metaphorically stop the clock; photos suggest the eternity to be found in a split second. Photography provides a way to capture the moment and freeze time, to make our ever-changing world stand still.

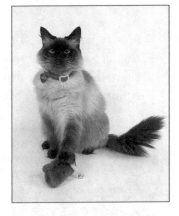

Figure 1.2 Cat and mouse. Latte, our Himalayan cat, has earned her share of cat food with this pet portrait, taken on a background of white seamless paper.

With the advent of digital imaging, photography takes on a whole new meaning, combining the best of both worlds—the technical and the artistic—and giving countless people a new way to express themselves. However, a foray into the electronic world reveals that it has much more in common with traditional photography than most people realize. When it comes to taking pictures, digital imaging and photography share many challenges. The real difference comes after the shooting, when you are processing images on your computer. Chapter 7, "Taking It to the Next Level," will explore this further.

Photography has also of late become a focal point for those involved in scrapbooking, Polaroid manipulation, and the art of hand-coloring black and white images. To these crafty folk, photography is a means to an end. It supplies the material for their art, a form of expression that deals with how to best present their images long after they've shot them. You'll find more on that in chapter 7 as well.

> *Just because I don't know doesn't mean I don't understand.*
>
> —Homer Simpson

For many, photography is a great excuse to get out and appreciate nature. It prompts people to take enough time off to enjoy an inspiring sunset or weekend in the mountains that is good for the soul. Photography gives parents a way to share their outdoor experiences with their children and their children's children. For animal lovers, photography gives us a way to "capture" an animal without turning to hunting.

While exploring any aspect of the world—whether a microcosm in your own backyard, a grand expense at a national park, or an exotic town with narrow cobblestone roads—photography lets you get creative and more deeply enjoy your environment.

Photography also teaches you how to see the world around you. You learn to notice such elements as light, color, shadow, and reflection. While most people take such aspects for granted, you—as a photographer—will more greatly appreciate these simple, beautiful elements of our visual world.

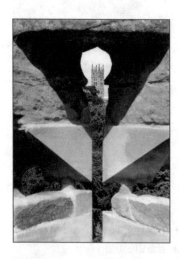

Figure 1.3 Arrow holes in Warwick Castle, England. Graphic shapes like the triangles can make a great picture in and of themselves. Photo by Denise Miotke

It is true that photography is rooted in a chemical, technical, and scientific history. However, only when the technical and the artistic come together does photography truly become a part of your life.

What Photography Is Not

Top Ten Myths About Picture Taking

1. **Photography Takes You Away from All the Action**
 Some people like to say that they prefer living life instead of just taking pictures of it. Now, that's not very nice, is it? Nor is it true. Photography actually gets you *more* involved in your environment, gives you a great excuse to talk to other people, sometimes helps shy people interact with others. Most of all, photography gets you out of the house and into the sunlight, where a lot of the action occurs in the first place.

2. **Photography Is Too Technical and Difficult**
 Far too many people suffer from photographic low self-esteem. They think of themselves as bad photographers simply because they don't understand all the technical details. This myth is perpetuated by the fact that most photography how-to books you see on the bookstore shelves are thick and technical. They assume you have all the time in the world and care about things like reciprocity and developing formulas. Snooz-o-rama! Let's leave these books to the people who actually enjoy doing homework.

3. **There Is Only One "Real" Kind of Photography**
 Some photo schools, unfortunately, teach the kind of photography you may not want to learn, such as how to process your own film and make your own prints in the darkroom. If you don't like taking black and white pictures or developing your own film, you're not alone.

Many professional photographers rarely deal with these areas of the art. Don't feel ashamed if bumping around in the dark and smelling like stinky developing chemicals is not for you. If, however, such activities do sound attractive, by all means, look into enrolling in a film-developing class at your local college or high school.

To be a great photographer, though, you need not shoot in the same way old masters have shot. Time and time again, I've seen a budding photographer stop dead in his tracks—never to reach for his camera again—simply because he believed he should do everything the way so-called "real" photographers do it. You don't need to buy complicated and expensive equipment, convert the bathroom into a darkroom, or traipse around the desert bearing an enormous camera on your shoulder. This version of photography may not be your cup of tea.

4. You Need a Degree to Be Qualified

Fortunately, a Masters in Fine Arts is not necessary for you to become an excellent photographer. You don't even need to go to night school. Just learn a few basics, pick up your camera, and get out there shooting fun subjects and putting your new techniques into action. It is a practical art that's mastered only by practicing it.

5. It's Up to the Camera

It is tempting to think that the camera is responsible for great photos. Don't let yourself believe that you have no control over the results. With just a little training, you will become more qualified than your camera to make good picture-taking decisions. Even if your camera seems to automatically flash, focus, and expose with a will of its own, you are in the driver's seat. The more you learn about how photographs are made, the more control you will be able to exert. This translates to your getting better pictures more often.

6. You Need a Really Expensive Camera

You need not feel bad about making the most of a simple point-and-shoot camera. Rather than spending a lot on a fancy camera, you will be wiser to make the most of what you have or purchase only what you can afford.

7. You Should Use a Manual Camera

Setting your automatic camera in the automatic mode to take automatic pictures is perfectly okay. What's important is getting shots you want and having fun in the process. If your camera can do this in the automatic (or "Program") mode, go for it. Understanding how to operate each and every button, knob, dial, and function on your camera is important only inasmuch as it helps you get good shots and have a great time.

8. Great Photographers Are Born Artists

Another falsehood that trips up some is that people are either predestined to be artistic or not. Creativity is not something in your genes; you are not necessarily born with or without a creative bent or proclivity. Skill is gained through conditioning and learning; anyone can develop talent by practicing new concepts and paying attention to results.

Take it from me. When I started photography, I had the artistic capability of a log. I chopped off people's heads, sometimes forgot to take the cap off the lens, and shot roll upon roll of rejects. I took it upon myself, though, to develop a system for getting better pictures each time I reached for my camera. And that is what you are about to learn.

9. There Are No Rules in Art

A whole generation of books on photography have been telling us that there are no rules when it comes to being creative. What an unfortunate leftover from

the Flower Power days of the 60s! When I was first learning, I just wanted someone to tell me where to begin. Many of my teachers, afraid of appearing strict and rigid, would remind me that "there are no rules in art." In fact, there are *many* rules, boundaries, and guidelines from which you can benefit.

10. And If There Are Rules, You Should Break Them
Another common saying is that "rules are meant to broken." This attitude results in nothing but reactionary art, one "school" of photography reacting to another. Instead, feel free to follow the rules, even embrace them. Decide for yourself whether following the rules and taking pretty pictures is more important than breaking the rules so you can make new and exciting artistic statements. In truth, even the most "rule-breaking" photographer does his or her fair share of obeying *some* set of laws.

One should never seriously look into taking pictures as a means to glamour, fame, and riches. For better or for worse, photography rarely gets one an appearance on Oprah, a chance to meet supermodels, or your first million. Trust me on that one.

Photography is not a lottery, either. Although it may seem driven by luck, your success has nothing to do with chance. Sure you have to be in the right place at the right time to catch that beautiful sunset, the fascinating close-up photo of a butterfly, or a picture of a crazy and colorful bird. However, luck doesn't play such a big role when it comes to getting great pictures. After all, you *decide* to look for colorful butterflies or exotic birds, you *set aside time* to enjoy gorgeous sunrises and sunsets. Most important, you *remember to bring the camera* along when you head out into the world!

Nor is photography confined to the technical. It's not necessarily about developing your own film and printing

your own pictures. Photography extends beyond the darkroom and entails much more than exposure times and enlarging lenses. You need never prepare your own batch of chemicals to be considered a great photographer. If such aspects of the art excite you, cool. Just don't let fear of or dissatisfaction with these aspects hold you back from diving into photography.

Lastly, great photography does not owe everything to the all-important camera. Many photographers get distracted by the gadgets, gazing hour after hour into catalogs and analyzing all the bells and whistles of various cameras. However, photography eludes a purely equipment-oriented definition. It is not about discussing the myriad details of expensive equipment. It never hurts to know your gear, but spending the bulk of your time bragging about titanium bodies and vertical shutters to your buddies at the camera store means that you are not out shooting at that moment.

While it's true that having excellent equipment plays a big part in picture quality, buying a great camera does not necessary mean you'll end up with great photos. As much as having a good camera helps, the true art is within you. That little black box, after all, does not take the pictures all by itself.

Getting great shots is not about luck, chemistry, or cameras; it is about being ready to take a great picture when a photo op presents itself. Great photography entails seeing the world with fresh insight and following a few simple guidelines when you go out shooting.

 ## FREQUENT PLEASURES, OCCASIONAL PITFALLS

There is no doubt about it—when your camera is operating as expected, and when everything is clicking just right and taking pictures is a snap, you will love shooting photos. At other times, typical frustrations can lead you to question your involvement in photography. But before we get into that, let's look at a few fun aspects of shooting photos.

Capturing the Moment: Getting That Great Shot

Getting a great photo is exhilarating. When you capture the moment or the essence of a person, place, or thing,

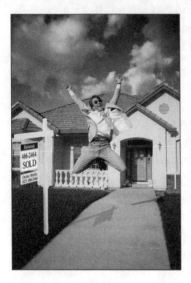

you feel a rush like no other. You sense that you have succeeded in making something new and extraordinary. This new image takes on a life of its own, becoming something much more than just a snapshot of a particular moment in time. Making images not only serves your purpose and satisfies your creative impulses; it enriches your experience of life and provides delightful memories of former places or times. You'll find much of the joy in photography in capturing those decisive moments.

Figure 1.4 Jumping for joy. Photo by Denise Miotke

Building Your Collection of Photographs

Taking pictures is enjoyable in itself, but the fun doesn't stop there. As you go about capturing decisive moments, you also are building a fascinating collection of exciting images and personal memories. Over the years, this plethora of favorite photos will grow into a wealth of stunning pictures that will give you great pride and satisfaction. As you take a passing glance at the family photos that line your hall or ponder past joys while sharing photo albums with friends and family, you will be reminded again and again of how much you enjoyed taking the pictures.

Instant Artist: Just Add Camera

Photography lets you be artistic even when you do not have enough time, patience, or skill to draw or paint. The word itself comes from the ancient Greek terms *photo* and *graph*,

Inspired to Invent the Instant

Trivia buffs will enjoy hearing how Dr. Edwin Land came to be inspired to invent Polaroid instant photos. In the late 1940s, while on a family vacation, Land's daughter wanted to see pictures taken earlier in the day. As much as Dr. Land tried to explain how he needed to first get the film developed, she did not feel satisfied with the answer. This got Dr. Land thinking, why shouldn't she be able to see her pictures immediately? The result was the invention of the Polaroid Land camera. Due to a little girl's impatience, the face of the photographic world was forever changed.

which translate to "light" and "painting" or "writing." Painting with light allows you to make wonderful photographic statements, even if drawing stick figures is out of your artistic league.

Photographic art is even more instant when you shoot with digital or Polaroid cameras. Both camera types offer you the ability to instantly see what you shot. This feature is great for beginners because it provides immediate feedback, telling you right away whether a particular technique worked or not.

Other Rewards: Making Friends and Fueling Scrapbooks

Sometimes, when taking pictures, you get to talking with people and make a new friend or two. You get to know places as well as the people or animals who live there. You are able to gather your own unique postcards when you travel and send personalized greeting cards during the holidays. Your scrapbooks become enriched with photographs that not only tell a story but also artistically express the nature of a place and the character of its inhabitants.

Now that you have a pretty good idea of what makes photography so much fun, let's quickly explore a couple of the frustrations you're likely to encounter. Rather than be overwhelmed by such frustration, you can learn how to solve many problems and quickly get back to the more pleasurable aspects of the craft.

Pitfall 1: Not Getting What You Want

The greatest frustration comes when, much to your surprise, the pictures simply do not turn out right. At times you've missed the shot because you are unable to react quickly enough. Perhaps you hit the wrong button—the zoom instead of the shutter button, for example. Maybe the camera disobeyed or misinterpreted your intention. Sometimes that darn camera focuses on the wrong thing; at other times, it makes the photo too dark or too light. And then there are times when people or animals get the red-eye effect. As automated as most cameras have become, even the best occasionally misread a scene. When you think you are going to get an especially exciting picture, learning otherwise after you pick up the prints from the photo lab is extremely disappointing.

There is still hope, though. You will find many ways to identify and overcome the problems of photographic technique in chapter 6, "Troubleshooting: Solutions to Common Photo Problems."

Pitfall 2: An Expensive Hobby

Taking great pictures—especially when done in a trial-and-error fashion—can get pricey. You need a camera you can work with and, if you shoot film, a new roll from time to time (and if you listen to my advice, you will not skimp on film!). Add to this occasional trips to the photo lab. You can minimize the amount of money you spend, however, by following the guidelines provided in the next chapter, "Buyer's Guide," as well as the hints found throughout the book. By

taking these hints to heart and shooting intelligently, you'll find that every cent you spend on the hobby will be worth it.

WHAT YOU SHOOT:
THE INFINITE ARRAY OF SUBJECTS

You can use photography to capture a rich variety of subject matter. You'll find many different subjects on which you can practice your art—from an orangutan to an old barn, from a friend's smile to a baby's first birthday cake. You can take wildlife pictures, serene landscapes, flattering portraits, and much more. The infinite array of options—each particular subject area has its own unlimited possibilities—keeps photography new and exciting. Let's take a look at just a few common subjects.

It's Only Natural to Love Landscapes

Landscape photography can capture practically any outdoor scene. In this category, you will see photos of mountain

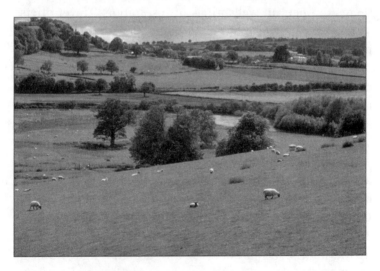

Figure 1.5 Welsh hills. Although outdoor landscapes are often comprised of pastoral scenes like this, they can also include more direct evidence of man's impact on nature.

peaks, high alpine lakes, flowing streams, waterfalls, or views of the ocean (called seascapes). Some even include hints of a more urban existence, such as buildings, telephone poles, street signs, or views of entire cities (called cityscapes).

You can define landscapes in whichever way you like. If you think telephone lines and stop signs are ugly or uninteresting, exclude them. People who favor symbols of pastoral life may prefer to shoot old towns or big red barns set against flowing fields of wheat.

Many beginning photography students are drawn to shooting landscapes of natural scenes because they think of them as what serious photographers shoot. There are, however, many other arenas to explore.

On the Road Again: Travel Photography

One fantastic way to enjoy photography is while you are on the road. Even though photographing subjects in your own backyard may be much less expensive, visiting far-off lands seems to open up wellsprings of inspiration. Travel offers so many interesting scenes and sights. In addition to exposing us to subjects that are deservedly photogenic, travel seems to even make ordinary places suddenly become fascinating. Traveling can provide you with numerous opportunities to take photos such as figure 1.6; you are only limited by your imagination and how much film you carry in your luggage.

Travel and landscapes often blend into each other. You are bound to take some scenic landscapes whether you are driving through a national park or island hopping in Greece. In fact, travel embraces all arenas of photography. At one minute you will be shooting architectural shots such as the interior of an abbey (see figure 1.7), and the next minute you might be snapping a candid picture of a priest, museum guide, friendly tourist, or military guard.

Most people take at least a few pictures when they travel. Keep the tips that follow in mind, and your slides or prints

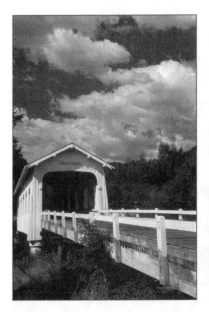

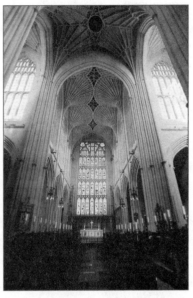

Figure 1.6 Grave Creek bridge. While traveling down the Oregon coast, we happened upon this beautiful historic bridge. The partially cloudy sky added dramatic interest to the scene.

Figure 1.7 Bath Abbey interior in England. A wide-angle lens allows you to get expansive views of interiors, vistas, and many other scenes. By setting my camera up on a tripod, I was able to capture the intricate ceiling architecture—amazingly carved out of stone—in this ancient church.

will be more satisfying, engaging, and fun for others to view. We'll start exploring the methods, which are surprisingly easy, in chapter 3.

Our Furry Little Friends: Animals and Pets

Pets are another endless source of photographic inspiration. The fact of the matter is that great pictures, like great books, are more likely to be inspired by subjects we love. And animal lovers, by definition, love animals and pets.

Pets can be especially hard to photograph well. They tend to move around a lot and change their position quickly. In order to photograph these subjects well, you need an infinite amount of patience, the ability to juggle more than a

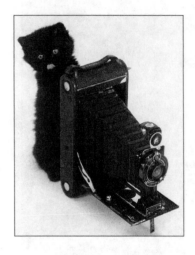

Figure 1.8 Kitten with camera. A neighbor friend lent us her new kitten one afternoon for portraits. With a simple white background, distractions were eliminated so all the attention could be focused on our new furry little friend.

few things at one time, and the ability to grab and keep your subject's attention. Having a lot of love for the little critters will go a long way toward helping you achieve your goals. When you do, though, you will find getting great pictures of your pets extremely enjoyable and rewarding.

Making Faces: People and Portraits

People love to look at pictures of people. From the fascinating candid picture of a man interacting with a street vendor to a more staged portrait of a farmer you meet while traveling, pictures with people in them particularly capture interest. We stuff family photos into our scrapbooks, set them on our desk to remind us why we go to work each day, and pull them out of our wallet at the water cooler. Professional photographers take pictures of people to fill countless market needs, shooting everything from weddings to families to fashion models.

Besides the usual challenges of the art, photographing people also requires social skills and the ability to overcome fear. Wedding photographers, for example, must be especially able to remain calm under the stress and strain of getting good photos of the eventful day. Regardless of what kind of people photography you are doing, though, you must break through privacy bubbles and shyness—your own as well as that of your subjects—to take great pictures of people.

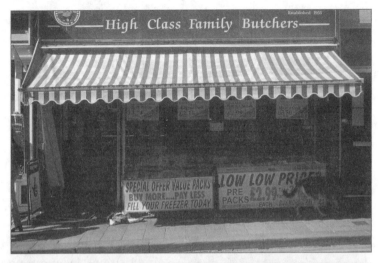

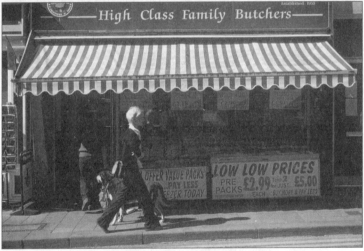

Figures 1.9 and 1.10 Butcher shop and passerby. Attracted to this storefront, I set up my camera on my tripod and prepared to shoot. Just as I was ready, a person walked by and added a valuable bit of human interest.

Most of us love to snap pictures of our family and friends. Even with snapshots, though, where the most blurry or dark photo can still succeed as a personal memento, we can learn tips and shortcuts for making them better. We can learn to more consistently capture fascinating expressions and make truly flattering portraits—a wonderfully worthwhile skill to

Figure 1.11 Portrait taken in England. Overcast sky and diffused light can actually be a big plus when it comes to taking portraits. For this shot, my wife stood near a doorway so I could take advantage of the flattering, diffused light.

have as you go through life. Flipping through albums filled with great photos of people is enormously satisfying.

Those are just a few of the various subjects you can photograph. Understanding the tools you use to photograph them can further help you appreciate the art. So let's take a peek at the tools that a photographer puts to use.

PHOTOGRAPHER'S TOOLS AND HOW THEY WORK

Painters apply paint to a canvas with brushes. Photographers trap light beams on film with a camera. Every artist has his tools and, despite the advanced technology involved, a photographer's tools are as fundamental to defining his art as are the tools of a painter.

To finish our first look at photography, let's meet the photographer's main tools—camera, film, and flash—and explore how they cooperate to capture images.

The camera, on its most basic level, is only a light-tight box with a little hole in it.

The Adobe 7000 Extremely Large-Format Camera

Let's pretend you're in front of a small, one-room adobe house somewhere in a quaint Southwestern town. You see no doors or chimneys in this adobe hut; the only opening is

one small window. Furthermore, a pair of shutters is closed so tightly over this window that no light is getting inside.

Being of a curious nature, you find a way in—let's say from an underground tunnel. Once inside, you find yourself in a pitch-black room—not just dark, but you can't even see your own hand in front of your face. Yikes!

You baby-step your way to the wall, feeling your way around with your hands. You touch the wall that is opposite the one with the little blocked window. All along the wall's surface, you feel a smooth, "filmy" texture, as

> *I've finally figured out what's wrong with photography. It's a one-eyed man looking through a little 'ole. Now, how much reality can there be in that?*
>
> —David Hockney

though the wall is covered with some kind of plastic. This adobe house represents your basic camera.

The adobe's window is like a lens, and the black shutters covering it are much like a camera shutter, the part that opens and closes when a picture is taken. If you open the shutters to the adobe for a brief moment, the light will come into the room and hit—or expose—the film on the far wall. When you close the shutters, the room returns to its pitch-black state.

This is where, to me, the science of photography becomes most fascinating. The directional light coming in through that window, even when it is opened for only a split second, creates an upside-down and backwards image of the scene outside. This really happens! If the wall with the window, for instance, faces an outdoor farmer's market, a picture of that scene would appear on the back wall of the house when the window is opened.

Film—It's So Sensitive

Film simply acts as a removable, light-sensitive material. It reacts to the light. Wherever beams of light hit the film, the qualities of that light are permanently recorded.

Because the film is grabbing light beams, things tend to go wrong when either too much light or too little light hits the film. Too much light makes the image look like heaven in the movies—everything glowing in bright white. Not enough light makes the picture look dark.

Even after you take a picture and expose the film to a scene, you cannot actually see the scene on the film until it is developed in a particular set of chemicals. After that little hole is opened for a moment, a photo is recorded on the film, but that image is invisible to the naked eye. This picture—which photographers call a *latent image*—is truly there, but we have to accept the fact on faith alone. We are only able to see this picture with our own eyes after the film is developed in special chemicals.

Furthermore, you would not want to try to see anything on undeveloped film because holding the film out in the open—even if only for a second—would flood it with too much light and ruin it. If you were to turn on the lights in that little adobe chamber, the film would be totally exposed and rendered useless.

Flash of Lightning

Sometimes a dark cloud comes over our adobe hut and the sun needs a little help. This is where an electronic flash comes in handy. This little device gives the scene a momentary blast of light—like a flash of lightning—that illuminates the details in the scene. Furthermore, this blast of light is so fast that it will, in the final image, help freeze any movement, such as that of a young boy running through the farmer's market. Without the flash, this boy may record in the photograph as a blur of activity; with the split second of bright light, he will more likely be recorded in perfect sharpness.

Now that you know the tools, subjects, pleasures, and pitfalls of photography, you should have a pretty good understanding of what photography is all about. From the man-

ner in which light is caught on film to the way images seem to appear out of nowhere in the darkroom, photography is full of excitement, magic, and suspense.

Before we get to taking pictures, though, we need a camera, and, unless we are shooting digitally, we need film. So let's examine the various kinds of cameras a photographer might use and learn how to select the best film.

Buyer's Guide

Deciding which kind of camera to buy can be an overwhelming task. Purchasing this useful device, however, need not frighten anyone. This chapter will help you make your initial choices without spending your kid's college fund or ending up with a relatively expensive paperweight.

In fact, I'll bet that you already own at least one camera. Even if it is not the best, you can begin with what you have. You can even use single-use, or throwaway, cameras to get the ball rolling. Letting equipment come between you and your pictures is a much greater sin than using a cheap camera. This chapter will help you either make the most of the camera you currently own or buy a better one. It will shed light on how equipment works and show you the basics of navigating your way around a camera.

> "Caution: Cape does not enable user to fly."
>
> —Batman costume warning label

Although a few photographers rely on the least expensive solutions, others invest in extremely expensive equipment. This chapter will show you how to balance cost with quality and buy only what you need in order to get great pictures.

First, we'll examine the various kinds of cameras to choose from—35mm point and shoots, SLRs, and digital cameras—and examine the pros and cons of each type. Then we'll take a look at a few other types of cameras as well as a list of the top ten questions to ask when purchasing a camera.

Unless you end up buying a digital camera, you will still need to choose which film you would like to use. Therefore, we will finish off the chapter with some guidelines on selecting the best film.

Let's begin looking at the various kinds of cameras.

> ## Helpful Hint
>
> If you realize that you haven't taken your camera out of the closet in a long time, ask yourself why. If you are frustrated with how the pictures rarely turn out right, use the tips and techniques in the following chapters and consider upgrading to a better camera.

 ## THE RIGHT CAMERA FOR YOU

There is no one best camera. That is like saying there is one best shoe or one best ice cream flavor . . . for everybody. Each camera has it's own strengths and therefore has a most fitting purpose or application. For some, a 35mm point and shoot camera may be the most fun and produce the best results. Others may be frustrated with anything less than a professional camera.

You can enjoy taking pictures with any camera—from a $10 throwaway to a $3,000 digital camera. The real danger is in buying a camera that quickly becomes neglected, only collecting dust in your closet. You can keep this from happening by understanding the various kinds of cameras so you can tell which one would be most likely to remain applicable and satisfying to your own needs.

So Many Cameras, So Little Time . . .

It's true. You have to be a bit of a bold person to go camera shopping. Staring at a wall of cameras can seem like facing a tidal wave. After all, the cameras all look similar. Picking the right one requires a great deal of thinking. You'll have many questions that need to be answered, preferably *before* you visit the camera store.

Furthermore, until you have spent a fair amount of time taking pictures, you probably won't know what kind of camera you like to use. On the other hand, you can't take many pictures until you get a camera. The way out of this chicken and egg conundrum is to ask the right questions and identify the issues that are most important for you, before you find yourself in a camera store. If you don't address these issues, you can easily end up buying a camera that does not best suit your own particular needs.

 ## WHICH CAMERA TO BUY: THE SHORT ANSWER

If you are heading to the camera store in a few minutes and don't have the time to read the remainder of the chapter, here is an Express Line answer for you:

If you want to get into photography as a hobby, spend an extra $100 to $300 and get a 35mm SLR camera with a good zoom lens.

If you are tight on cash, don't know how far this photography thing will go for you, and/or need a camera that fits into your shirt pocket, explore cameras in the 35mm point and shoot variety. A camera with a zoom lens will be much more versatile but will likely cost about $100 to $200 more than one without.

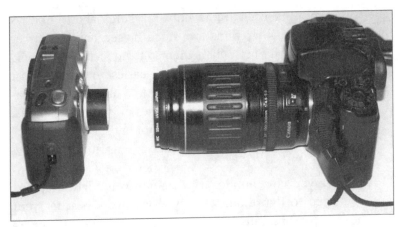

Figure 2.1 Showdown at high noon: SLR vs. the point and shoot camera

WHICH CAMERA TO BUY: THE LONG ANSWER

Now, let's dig in and sort out this whole camera question. Within a short time, you can narrow down the choices and gain the advantage you need *before* you find yourself staring at all those little black boxes.

You probably have already made the most important decision about buying a camera—without even knowing it. This first decision has to do with what kind of film you put into the camera (if you put film in it at all).

35mm Film vs. Other Film Formats

Easy to find in almost any grocery store, 35mm is by far the most popular size of film available today. The 35 simply refers to the width of the film, in millimeters.

There are a number of film sizes and shapes, and most are also measured in millimeters, for example, 16mm or 70mm. Other film types are called something else altogether, like APS (Advanced Photo System), Polaroid, or 120.

As far as size goes, 35mm is pretty small. Although it is bigger than spy film (used in those tiny cameras seen in *Mission Impossible* or the James Bond movies, for example)

and APS film, each frame only measures about 1 × 1.5 inches. Some other films are much bigger, and the larger the film, the sharper enlargements of the picture will look. 35mm film, though, has become the easiest to use and most convenient choice over the past century, able to deliver satisfying colors and sharpness. It pleases most photographers, keeps the shooting simple enough for almost everyone, and, above all, is compact. Many 35mm cameras fit into a pocket or purse.

Once you have an idea of what film you might use, next you need to figure out what type will work best for your needs. For absolute beginners, the multitude of camera choices can be narrowed down to four camera groups: point and shoot, SLR, digital, and everything else.

35mm Point and Shoot

The simplest cameras are also the most popular. These compact cameras ask the photographer to make only two decisions: which direction to point and when to shoot. Thus the name: point and shoot. You can choose from a number of cameras in this category, such as the Olympus Stylus, Pentax IQ Zoom, and Canon Sure Shot.

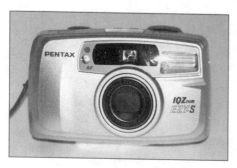

Figure 2.2 Point and shoot camera

There are many other kinds of cameras—from SLRs to Polaroid instant cameras to digital cameras that allow you to "point and shoot." When people refer to a point and shoot, however, they usually mean a compact and completely automatic 35mm camera.

These cameras may be best suited for people who want to take pictures only occasionally. If you want photos of family parties and snapshots from vacations—taken with the sim-

plest, most compact, and most foolproof camera—the 35mm point and shoot is the way to go.

Simplicity at Its Best　Point and shoot users can often get by without ever having to open their owner's manual. These simple cameras are great for those who can't stand dealing with technical complexities.

Because all the photographic decisions are being made by the camera, point and shoots may not be ideal for those interested in learning how to make artistic statements. If you already have a point and shoot, however, you may still be able to use it to learn the art. The better, more expensive point and shoots utilize high-quality lenses to capture sharper, more pleasing photos. Some offer the ability to select special modes and control whether the flash fires or not. In the beginning, though, almost any point and shoot camera should work fine for learning the basics of how to shoot.

A Camera with a View　Near the top of the back of each camera lies a small window, the viewfinder. By looking through this window, you'll get a rough idea of your potential photo. With a point and shoot camera, you do not look through the lens itself, so as you get closer to a subject, you see a slightly different area through the viewfinder than the camera sees through the lens. To many users' surprise, this often results in the subject of their picture being off-center or only partially photographed.

Point and Shoots with Manual Override　A very few high-end point and shoots do allow you to control aperture, shutter speed, focus, and lighting options. These more expensive point and shoot cameras are popular with photographers who shoot often, need high quality, and like the simplicity and compactness of point and shoots.

But what if even the most flexible and powerful of point and shoots is not enough? What if you find them

frustratingly limited or yearn for a little more control when taking pictures?

SLR—The Road Less Traveled

Most people are less familiar with SLR cameras than they are with point and shoots. All the same, SLRs are a popular camera type among serious hobbyists and a favorite among wildlife photographers, photojournalists, sports lovers, and many others.

What's an SLR? SLR stands for "Single Lens Reflex." With an SLR, you actually look through the lens itself as your viewfinder, which is why it's called "single lens." Because you are looking through the same lens that is used to expose the film, you see in the viewfinder a good representation of what you actually end up getting in a print. What you see is what you get.

This camera is best for people who want more from their photos and feel comfortable with a bit of technical complexity. Examples of this camera type include the Canon Rebel and Elan series, the Nikon N series, and the Minolta Maxxum series.

The Advantages of SLR With an SLR, you can control the focus so that you select which parts of the picture are sharp and which parts are not. Many students use SLRs to learn how to control aperture and shutter speed for proper exposure. With an SLR, you can get special effects such as these:

- Blur the brake lights of cars passing in traffic.
- Get an interesting, smooth water effect with rivers and waterfalls. See figure 8.6 for an example of the kind of picture I am talking about.
- Take pictures of fireworks, lightning, and other tricky subjects.

You can shoot quickly with an SLR, making it ideal for wildlife and sporting events. Although a tripod is often re-

quired to get the sharpest results, most situations can be successfully photographed without one.

Other advantages include:

1. The Ability to Switch Lenses

Unlike most point and shoots, which are one complete camera in themselves, SLRs usually consist of two parts: the lens and the body. Most entry-level SLR camera kits come with both a body and a lens, but sometimes camera bodies and lenses are sold separately. I recommend buying a lens from the same company that made your camera rather than buying a third-party lens produced by another manufacturer. This will often ensure the sharpest results and the fastest, quietest focusing. These do cost more, however, and many photographers on a budget are perfectly happy with third-party lenses.

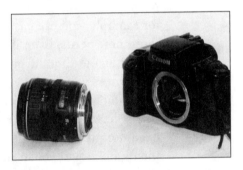

Figure 2.3 SLR camera next to a separate lens

The cool thing about having separate parts is that you can change them on an SLR to get different effects. For example, you can do these things:

- Photograph extremely distant subjects such as an eagle high up in the trees with a telephoto lens.
- Shoot an expansive vista or the interior of a tight room with a wide-angle lens.
- Get close-up or life-size photos of tiny things like bugs with a macro lens.

By simply switching lenses, you can go from shooting an amazing little ladybug to capturing the joyous expression on your kid's face as she scores a goal. While

you can get some flexibility with a zooming point and shoot, a 35mm SLR offers a much wider range of options, including specialized lenses such as fisheye (that can capture round, 180-degree views, like looking through a fish's eye), telescope and microscope adapters (that let you photograph the cosmos or microcosms), and more.

2. Scalable Simplicity

Most SLRs are designed with future expansion in mind. Different options are available with regard to flash, timers, multiple-exposure, studio lighting set-ups, fast motor drives, . . . the choices are endless. If people start asking you to shoot their wedding photos, for example, you can easily adapt your camera to meet those new needs. Even if such an idea never occurred to you at the time of purchase, these SLRs can grow with you as you grow.

Although most SLRs can be adapted in this way, it is still a relatively simple routine to use one. An SLR need not present any more complications or problems than a point and shoot. In fact, many SLRs can be set on an easy automatic "program" mode while you learn to make more challenging photographs. In this mode, they operate just like a point and shoot; yet you also have the option of expanding the camera or going into a more manual mode when you are ready. Your early photo shoots won't be as frustrating, *and* you can come home with wonderful pictures from the beginning while learning and mastering advanced features as you go.

The Main Disadvantages: The Bulk Without the Discount
35mm SLR cameras have two downsides:

1. They are usually a bit bulkier and heavier than a point and shoot.

While you can often slip a point and shoot into your pocket, an SLR will probably require a separate carrying case or shoulder strap. If, in all honesty, you do not see yourself carrying a big SLR around, by all means, get a point and shoot. A camera does no good if you never feel like taking it with you.

2. **They generally cost a bit more.**
 While you can buy a great point and shoot for under $250, new SLRs usually start at around $350 and up. You can, however, get used, manual-focus SLRs for around $150 to $300.

The Need for Speed: Digital Cameras

Now let's turn our attention to cameras that use no film at all. Digital cameras open up a whole new world of photographic possibilities and are especially appropriate for those who need immediate gratification when taking pictures. Let's take a look at the pros and cons of going digital.

Look Ma, No Film

What you hear is true: digital imaging has taken the photography world by storm. Instead of using film, the camera records images electronically. The images are stored, viewed, and manipulated on a computer and usually printed out via a home printer. Although there are hundreds of models available, a couple of examples might be the Kodak DC series or the Canon PowerShot series.

Ask around—you will find that almost everybody

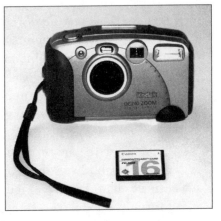

Figure 2.4 Digital camera and the "film" it uses—a Compact Flash memory card

has either bought a digital camera or has considered buying one, and for good reason. These cameras allow people to forget about film. Most give immediate feedback via a small LCD monitor on the back of the camera. They also empower photographers with the possibility of altering pictures with many new, creative treatments. With simple software programs, you can enhance, correct, or artistically overhaul your images at the touch of a button.

Rather than storing photographic images on film, digital cameras hold the pictures in computer memory—either in a little, removable card or hard-wired into the camera itself. As soon as you take the picture, you can transfer photos right onto your computer. You can then e-mail them, post them to a Web site, or print them on your own computer printer.

Because you avoid the costs of film and developing, you can save a substantial amount of time and money by shooting digitally. You also no longer need to take negatives or prints into a photo lab to be scanned when you want to digitize your photographs. To be fair, though, digital imaging has its own costs; for one thing, you may end up spending a lot of time and money on your computer, your printer, ink cartridges, paper, and more.

Like a Point and Shoot, Only Different Although digital cameras cost much more, most can be compared to fairly simple, inexpensive point and shoot cameras. The expensive electronic technology inside these cameras makes them a hard item for manufacturers to build on a budget. In an effort to keep costs down, they often skimp on the more creative controls and features.

Some of the more expensive digital cameras give you more control. Even then, operating these creative controls can be more laborious and difficult than other cameras—forcing you to follow a complicated set of instructions, press a bunch of tiny buttons, and drill down multiple menus in order to change settings.

In most digital cameras, composing your picture involves looking through a separate viewfinder, much like when you use a film-based point and shoot camera. These cameras usually have one, attached lens—either fixed or zoom—and most models have an automatic, built-in flash.

As far as photographic technique is concerned, a digital camera is as easy to use as a point and shoot. For this reason, the tips and techniques in the following chapters will help both digital camera users and those who shoot with film-based cameras. The main differences between 35mm point and shoots and digital cameras have to do with high-tech characteristics and concepts such as compression ratios, pixel resolution, file formats, transfer rates, and such. Other than that, taking great pictures on one kind of camera is much like taking great pictures on the other.

The Main Advantage: Instant Gratification A digital camera can save you a great deal of money—money that you would have spent on film and developing. However, other expenses—such as the cost of printer papers and inks—can outweigh these savings.

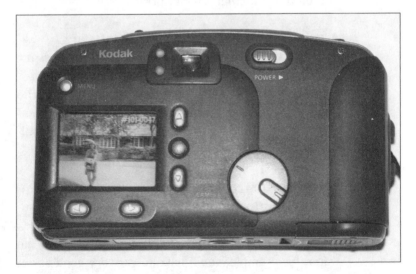

Figure 2.5 A digital camera's LCD monitor showing a picture

Therefore, the real advantage of using a digital is that you get to see results much more quickly. You don't have to take your film to the photo lab and then wait for your film to be developed. In addition, in most cameras, you get to see the image immediately after taking it, by way of a small screen in the camera. With this immediate feedback, you can see right away whether or not you succeeded in getting the shot. If you failed to get the shot you were after, you are free to erase the image and re-shoot.

This is an especially wonderful feature for beginning photographers. Because they can see the effects of various techniques immediately, beginners can correct mistakes at the time of shooting and learn more quickly.

A Few Disadvantages: Cost, Complication, and Delay Users have three common complaints about digital cameras:

1. **Compared to film-based cameras with similar qualities, they cost more.**

 Inexpensive models are available, but they generally either lack critical features or do not have enough resolution to create high-quality prints.

2. **A good color printer and special software to manipulate the images on your computer is necessary before you can print them successfully.**

 It can be intimidating to find one's way around all the high-tech choices, and making prints from your computer that compare to the quality you get from a traditional photo lab can be extremely difficult.

3. **There is often a delay between the moment you push the button and the moment the camera actually takes the picture.**

 If you are photographing a dolphin jumping out of the water, for example, you'll have to get very good at an-

ticipating the jump in order to catch the picture. If you push the button while the dolphin is in mid-jump (or even just popping its head out of the water), he will likely be back under the surface by the time the camera fires, and you will have missed the shot.

Therefore, these cameras can be less than ideal for photographing fast-moving subjects, making photo-quality 12" × 18" enlargements, or shooting on a shoestring budget. Otherwise, digital cameras present many creative and convenient picture-taking opportunities.

Everything Else: From APS to Instant

There are many other popular cameras that do not fit neatly into the previous categories. Although the majority of cameras these days are of the point and shoot, SLR, and digital varieties, these other popular camera types are going strong. They include but are not limited to APS cameras, Polaroids, throwaways, and medium format cameras.

APS—Advanced and Easier to Use

A big up-and-comer in the camera market is the APS (which stands for "Advanced Photo System"). One benefit to this type of point and shoot camera is that it is virtually impossible to load the film wrong. The film cartridge has a slightly irregular shape that allows the user to fit it into the camera in only one particular way. Examples of APS cameras include the Nikon Pronea and the Canon Elph series.

Another advantage of the APS: It allows you to choose between three different print sizes. By simply flicking a switch, you can select regular, slightly wide, or panoramic-size prints. Thus one picture can be an expansive wide view of the Grand Canyon, whereas the next one can be a regular size portrait of your spouse. This flexibility adds a lot of fun to your picture-taking experiences.

A Self-Contained Package:
Instant Cameras

Many people will find it a relief to know that you don't need to own an expensive digital camera to enjoy instant gratification while taking pictures. Polaroid photography delivers results almost as instantaneously and requires no understanding of Microsoft Windows whatsoever.

Using an instant camera is like having the film, the photo-finishing lab, and the print all in one neat package. Its film has all of the developing chemicals inside of each print. As soon as you take the picture, the processing of the image begins. Within a minute or two, you get to see the photograph. You can find examples of instant photography adorning the inside cover of your passport or in the photo booths you sometimes see in malls.

Instant cameras are a lot of fun. They offer an easy-to-use, inexpensive, and convenient option for people who would like to bypass the photo lab, get immediate results, and resist the urge to get a digital camera. One drawback to keep in mind is that you can't easily get reprints from the pictures taken with a Polaroid. Having no negatives makes it hard to get high-quality reproductions.

Camera in a Box:
The Disposable Camera

Also known as single-use, cardboard, or throwaway cameras, disposables are designed to make photography as easy as it can possibly be. They use fast-speed film and simple technology to increase the odds of success in a variety of situations. The results from a disposable camera can be surprisingly good, considering how simple they are.

Many brides and wedding planners like to put a flash-enabled disposable camera at each table during the wedding reception so guests can take candid shots. Waterproof models offer the least expensive way to dip your toes—figuratively speaking—into the art of underwater photography. On

Travel Light

When traveling with a disposable camera, you can minimize your load by getting rid of the bulky container as soon as you are done shooting. After taking the final picture, rip away the cardboard wrapper, use a coin to open up the plastic container, and remove the roll of film inside. Discard the container or, better yet, drop it off at almost any photo lab to be recycled.

a bright day, waterproof disposables can give you great mementos of your snorkeling adventures.

Another fun variety is the disposable panoramic camera. Taking a panoramic disposal along on your travels is a fun way to supplement your regular photos with long, thin pictures.

For beginning students of photography, the main drawback of throwaway cameras is that they don't allow the user to make many artistic choices—they are as automatic as it gets. Also, disposable cameras generally don't focus on objects within 4 feet of distance, so don't plan on getting any extreme close-ups with one. Disposable cameras with a flash don't illuminate things more than about 12 feet away; therefore, these models may give the best results when your subject is within this 4- to 12-foot range.

Big Time: Medium- and Large-Format Cameras

On the other end of the spectrum, medium-format cameras are much more complex and use much larger size film than 35mm cameras. The larger size films appeal to people who frequently like to have their photographs

blown up to 8" × 10" and larger. With this bigger film format, photographers can make huge enlargements with satisfying clarity of detail.

Large-format cameras, such as 4" × 5" or 8" × 10" cameras, take photos that can be enlarged to even bigger sizes. The color, sharpness, and ability to capture light and detail is amazing, if done right. Ansel Adams used this type of camera.

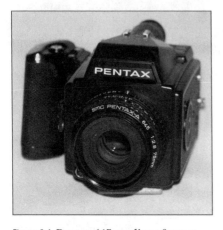

Figure 2.6 Pentax 645 medium-format camera

I don't recommend large-format cameras for beginners. They are expensive, challenging, and require a Zen Buddhist degree of patience. Now, if Aunt Edna picked one up at a garage sale and gave it to you as a gift, a medium- or large-format camera can provide an exciting way to get into the art.

So there you have it—the four main camera groups with most beginning photographers using the first three choices—35mm point and shoots, digital cameras, and SLRs. Ultimately, the decision comes down to whether you want a compact, simple, and somewhat limited camera or a bigger, more expensive, and expandable camera.

The next factor to consider when choosing a camera is the type of lens it features.

Going to Great Lengths: Zoom Lenses and Various Focal Lengths

Lenses play a crucial part when it comes to getting great pictures. These pieces of glass most directly affect image quality and sharpness. As mentioned earlier, point and shoot cameras usually have a fixed or a zoom lens incorporated into the camera itself; SLR units, on the other hand,

are connected with separate lenses to allow an even wider range of options than the best of point and shoot cameras.

Focal length indicates the magnifying power of a lens. Lenses that fall within certain ranges are grouped into normal, telephoto, or wide-angle lenses. Look at the examples in figures 2.7 through 2.9 to see how each range effects the photos you take.

As you can see from the examples, lens selection greatly affects your resulting image. Wide-angle lenses, in the 17mm–35mm range, are great

Figure 2.7 28mm wide-angle lens length

Figure 2.8 50mm normal lens length

Figure 2.9 160mm telephoto lens length

for shooting expansive, panoramic vistas or tight interiors such as inside museums or homes. 28mm is generally the widest a point and shoot zoom will go, with most of them going to only 35mm. SLRs, on the other hand, can use lenses as wide as 14mm or less. A normal or standard lens has a focal length of roughly 50mm–60mm. With it, scenes look about the same as they do to the naked eye. You can magnify subjects to a larger than life size with a telephoto lens. Telephotos are generally around 80mm–160mm for point and shoots. SLR users usually consider 100mm–300mm or higher as telephoto.

Zooming Right Along

A zoom lens allows you to quickly magnify or shrink your subject, going from wide-angle to telephoto with a simple movement of your fingers.

Many point and shoots have a built-in zoom lens that will allow you to get a little closer to or a little farther from the subject. Even though point and shoots with zooms cost more than those without, they are worth every penny. Having the ability to recompose your photo on the fly and fill the frame with your subject makes these cameras worth the extra cost.

Even if you get a point and shoot with a zoom lens, you have yet another choice to make. Zoom lenses come in two varieties: ones that allow you to continuously zoom throughout a range and ones that only give you two or three choices. Because they give you the most compositional options, a continuous zooming model is much better than a two- or three-step lens. There is much more creativity to be had in choosing from an infinite range than being forced to select between "wide," "medium," and "telephoto."

SLR users have many more choices when it comes to zoom lenses. They can buy ones that range from 35mm to 200mm and beyond or lenses that hover around one area. For example, a 17mm–35mm wide-angle zoom allows shooters to get both slightly and extremely wide-angle images.

Up Close and Personal

Macro modes and lenses let you get much closer to your subject than does a typical lens, so you can take interesting close-up photos. These lenses are great for photographing insects, stamps, and other small objects.

Now that you know more about camera types and lens options, you can apply this new knowledge to your own unique situation. Because each camera has its own niche, the next section will help you custom-fit the perfect camera to your individual needs.

Top Ten Questions to Ask Yourself Before Buying a Camera

The following questions are designed to help you narrow down the choices. Answering them before you visit the camera store will help you make the wisest decision.

1. **What kinds of cameras have you used in the past?**
 Considering the kinds of cameras that you have previously shot with can help you pick the best camera for future photographic endeavors. What did you think of them? If you have been pretty happy with a past point and shoot, for example, you may enjoy buying a similar kind of camera. If you were unsatisfied or are now ready for more, you might like a 35mm SLR.

2. **How would you describe yourself?**
 Do you consider yourself artistic or pragmatic, adventurous or careful? The answers to these questions can point you in the right direction. Parents, or travelers who just want to get decent snapshots, for example, will likely be satisfied with a point and shoot. Teenagers or retirees looking for a career or a hobby might enjoy a 35mm SLR. Adrenaline-crazed bungee-jumpers, mountain bikers, and snorkelers may want an especially durable or waterproof camera such as a Pentax IQ Zoom WR (or weather-resistant) camera, a Canon Sure Shot A-1, or a Minolta Weathermatic Zoom.

3. What are you going to use the camera for?

Whether you plan to primarily photograph kids, animals, portraits, travel shots, architecture, sports, or concerts, knowing your subjects will help you identify the features you require. Photographers who like to shoot architectural interiors, for example, will want a wide-angle lens and will be really happy with one that doesn't distort things too much. Sports photographers will need a camera that takes the picture immediately upon pressing the shutter button, without any delay. Most digital point and shoots—with their notorious delays—will likely frustrate such photographers and be unacceptably underqualified for the job.

4. What do you want as your final results?

Do you envision yourself e-mailing photos, sticking them in an album or scrapbook, or framing your favorites and hanging them on the wall? A point and shoot should be satisfactory if you plan to get most prints smaller than 5" × 7". If you want to e-mail them, on the other hand, a digital camera would be the most obvious choice.

5. Do you want immediate results, and if so, do you own a computer?

You will probably already be considering a digital camera if you love things like gigabytes, the Web, and computer software applications. For those who value immediate gratification or potential savings on film and development, the digital solution may be just as ideal. If you need the immediacy but don't want the digital, look into a Polaroid instant camera. If you can live without the immediate gratification, focus your efforts on finding a good film camera.

6. Does the thought of handling film frighten you?

Have you ever taken the whole camera to the photo lab and asked them to take the film out for you? If you

shudder at the thought of putting film in the camera and taking it out again, consider an APS point and shoot camera.

7. **Do you like really big enlargements?**

If you like getting big enlargements, you might want to steer clear of an APS. Besides the fact that these cameras usually are simple point and shoots, the smaller APS film does not enlarge as well as 35mm. Then again, you might not be satisfied with 35mm; you might prefer an even bigger medium- or large-format camera.

8. **How close will you be to your subject?**

If you plan to shoot wildlife, you probably need a strong zoom. A point and shoot zoom (usually with an upper limit of around 135mm–160mm) will probably not do the job for you. You're likely to need at least a 400mm for birds and a 300mm for larger animals. Parents restricted to the sidelines, unable to get closer to their kid playing sports, will also appreciate the benefits of a strong zoom.

If, on the other hand, you are a traveler planning to visit lots of museums and other places—where you will often find yourself in tight quarters—a wide-angle will likely come in handy. You may want to look for a zoom that goes down to 28mm or less. SLR cameras will potentially give you the widest wide-angle lens options.

9. **Does size matter?**

It is important to determine if you are likely to bring the camera along even when it doesn't fit into your pocket or purse. If you don't mind the extra effort involved in lugging around a relatively behemoth camera, go for a 35mm SLR. However, look elsewhere if you feel uncomfortable carrying around such a big camera.

10. What is your price range?

Combine your answers to the first nine questions with your consideration for price. Keep in mind that this camera will be with you for some time, and its quality will have an effect on the quality of your pictures. An extra $100 can go a long way when it comes to buying your camera; the additional features and better quality lenses cost more but generally help you get clearer, more satisfying results.

Fun Fact!

Kodak's first mass-marketed camera, the Brownie, cost $1.

Because prices change all the time and could be inaccurate by the time you read this, visit the Web sites listed in the "Resources" section at the back of this book to get up-to-date information on the various price ranges.

The answers you give to these questions should help you narrow down the choices and point you in the right direction.

Taking It Out for a Test Drive

Once you are looking in the right direction, you can further define your preferences by trying out a camera or two. At this point in the buying process, the best way to know which particular model you most prefer is to hold them in your hands and see how each feels. Go to a camera store and pick up each camera to feel its weight. Does it seem too heavy or light? Too bulky? Do you like how it feels in your hands?

Fiddle with the buttons and attachments. Are they easy to read and move? Are they too small for your fingers to work? Do the locations of the main buttons and dials make sense to you? Or do you consistently fumble around, catching yourself looking for a button on the wrong side of the camera? Is looking through the viewfinder intuitive? If you are getting a camera with a zoom, is it slow and noisy or fast and quiet?

Get to Know Your New Camera

Try not to buy a camera right before heading out on a trip without first using it for a while. Give yourself a little time to get to know the camera before you travel. Try to shoot at least one roll of film and have it developed before leaving. This way, you won't make needless mistakes on your trip just because you have not yet practiced enough with your new camera.

Better yet, try shooting a few pictures with your potential camera. Ask the salesperson if you can take it for a test drive. Running a roll of film through your top camera choices is the ultimate way to see which one you like best. While some salespeople will resist, others will let you take pictures in or around the store.

Alternatively, you can look for a pro camera shop in your area that rents cameras. The cost of a rental and a few rolls of film is a small price to pay for knowing first-hand how much you like or dislike actually using the camera. Far too many people rush through the purchase process only to put the camera in a drawer after a few frustrating experiences. By trying the camera out before you buy it, you won't be surprised by features you don't like.

Now that we know what kind of camera to buy, let's take a look at another thing we will need: film.

 ## FEEDING YOUR CAMERA WITH THE BEST FILM

After buying a camera, selecting film might just be the second most likely thing to frighten away potential photographers. Perhaps this is because there are so many choices out there, or maybe it is because you have to plan so far in

How to Read the Markings of a Roll of Film

A) "C-41" marking indicates that this is a regular print film, where you can take the negatives into almost any lab and get prints back. B) "36" indicates length; there are 36 exposures on each of the rolls of film pictured here. C) "E-6," "Chrome," and "Transparencies" all indicate that this is a roll of slides. D) "800," "160," and "50" are the speeds of these three rolls of film. The 50 is a slow slide film. The 800 is a fast film that can be processed at your regular photofinishing lab. The 160 is also a print film, but it is much slower than the 800.

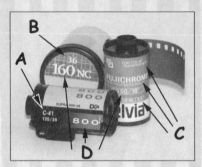

advance of the actual shooting. Whatever the reason, it is hard to pick a film.

To make this decision as easy as it can be, let's look at each feature of a roll of film individually. We'll start with a look at film speed.

Fast Film and Risky Business

Speed may be the most important aspect of the film you select. Speeds are rated in terms of ISO, and films with speeds of an ISO of 400 or above are considered fast. Films with an ISO of 100 or below are considered slow films because they take longer to become exposed by the light. Faster film works better in dimmer situations such as in museums and indoor concerts. Slower films require brighter conditions, but they usually create sharper and more colorful pictures.

When shooting in bright sunshine, an imperfect selection of film speed is rarely a big problem. Using an overly fast film like ISO 800 will only result in the picture appearing a bit dull and looking a little grainy, especially when enlarged. Graininess makes a picture look just a tad unclear because you can see tiny little dots in the photo. Because grain becomes more distracting as you enlarge an image, most people who usually get nothing bigger than 4" × 6" prints will be satisfied with a speed around ISO 400.

Using a slow speed film, especially with a point and shoot camera, can be much more risky. Although slow-speed film is what the professionals love, it can cause pictures to come out blurry when there isn't enough light. This problem is much more noticeable than having enlargements turn out a little grainy.

On a Long Roll: Film Length

35mm film usually comes in rolls of 12, 24, or 36 exposures. Most professionals prefer 36 exposures because it allows them to shoot a bit more before they have to load another roll of film. (This explains why most film branded as "professional" is only available in rolls of 36.)

People such as real estate agents and insurance adjusters, on the other hand, often like 12 exposures because they only need to shoot a few pictures before having the film developed. Select whichever film length you prefer most.

The Final Product: Slides vs. Prints

Choosing slides (AKA "chrome" or "color positive") or print film (also called "color negative") largely depends upon your end goal.

More people prefer prints because storing and viewing them is easy and convenient. Flipping through a photo album requires less set-up than presenting a slide show. Prints are ideal if you want to get print enlargements, whereas having prints made from slides can be difficult and costly.

Many travel photographers and others like to shoot with slides. Putting on a slide show, while it may require more preparation than flipping through a photo album, is more of an event and can be a lot of fun. Slides often produce more vibrant, richer colors. Also, they are more appropriate for photographers who sell color images to publishers, because most publishers prefer slides.

Slide film, though, can be challenging for the beginner to shoot. Print film is more forgiving; it allows you to make more mistakes than slide film. Print film, by its very nature, can produce decent images even when the exposure is not perfectly correct. Also, lab technicians can make some adjustments and corrections to further save an incorrectly exposed image while making a print from your negative. Exposures for slide film, on the other hand, need to be much more accurate.

Color vs. Black and White

Carrying along at least one roll of black and white film comes in very handy. For example, when there is not much color in the day to begin with, landscapes and travel images can look much more interesting when shot with black and white. It is also a great film for photographing people, candids, and atmospheric mood shots.

Two kinds of black and white film are available these days. The easier and cheaper type to get processed is specified as "Develop in C-41" and can be taken to almost any photo lab. Getting images from this type of film to look like traditional black and white photos, though, might be a bit trickier. They usually come out slightly brown, or

Helpful Hint

If you are struggling with shooting on an overcast day—and all your scenes are being ruined by the boring, dull gray sky—try using black and white film instead. A blown-out sky is much less obvious to the viewer's eye when recorded in black and white.

sepia-toned, like pictures taken in the 1800s. Ask your photo lab if they can print it on true black and white paper for less colorful results.

The alternative is to use true black and white film, but this is generally less convenient and more expensive to have developed. Instead of taking an hour or so at your local photo lab, the film is usually sent to a special lab and requires a couple of days to be processed. The results, however, can be stunning.

Brands and Sources for Film

Choosing a particular brand of film is largely a matter of personal preference. Some say that Fuji films are better for capturing bright greens and blues, whereas Kodak film is warmer and therefore better for capturing reds and oranges. In fact, though, both brands—as well as other brands such as Agfa and Konica—have various lines of film, each with its own characteristics. To most eyes—mine included—these distinguishing characteristics are often hard to see.

If you get a roll of film in the mail, check to make sure it says "Develop in C-41" before shooting it. Some companies send free film that is not C-41 and can only be processed in the company's own chemicals. Thus you are forced to send it back to them when you are done shooting it. Furthermore, these films are usually made from a different kind of material that many consider inferior.

When buying films through the Web or mail-order companies, you may want to make sure that your film is meant to be sold in your own country. U.S. shoppers, for example, can often buy films at substantially lower prices because they were intended for resale in another economy. This importing practice, called "gray market," is legal, but buyers can't be sure that the film was stored properly. When you buy film that was intended by the manufacturer to be sold in your country, you can be more assured that the film has been stored at its most ideal levels of temperature, humidity, and so on.

Brown Bananas

People often worry about the expiration date on film. Indeed, film is perishable. It may not go bad as quickly as the carton of milk in your refrigerator, but it does indeed change over time.

Unlike milk, though, film that has passed its expiration date is not necessarily unusable. The more overdue it gets, the more likely you will see slight color shifts. You can avoid this problem by storing your film in the refrigerator. Keeping it cold will prolong the life beyond the expiration date. Just let it "thaw" for an hour or two before putting it in the camera.

If your film has been in the camera longer than you can remember, you might want to take it out and have it developed before shooting more pictures on it. The cost of a new roll of film is much less than the price of a good photo ruined by bad film.

Keeping these few guidelines in mind, film will be among the least of your concerns. The bottom line is to pick one film and try it out. For instance, if you want to shoot pictures of people, try Kodak's Portra line. If you want to shoot vibrant, color-saturated slides, experiment with Fuji Velvia or Kodak E100VS.

Whichever film you choose to try first, shoot many rolls of this one type over the span of a few months to really get to know it. If you like it, stick with it. If you don't like it, try another. In the long run, you will be able to find the brands and speeds you like to shoot with the most.

Now that you have your camera and a fresh roll of film (or a digital storage card, as the case may be), you can move on to the fun part—learning how to use them. Fortunately for us, the techniques of photography are not at all difficult. Without further ado, let's learn a few of the basics. . . .

3

Better Photo Basics

Camera manufacturers like to make photography sound so easy that anybody can do it. They call their products "automatic" and have salespeople tell you that, with their camera, taking pictures is a snap. About a hundred years ago, for example, Kodak first started telling people, "You press the button and we do the rest."

For the most part, it's true that taking snapshots is easy. The problem, of course, comes when, instead of taking mere snapshots, you want to take *great* pictures. After coming home from the photo lab with less than exciting results, you understand first-hand just how slippery the term "point and shoot" can be. It is indeed easy for the average Joe to snap a picture, but most of us need a little training before we start turning those snapshots into beautiful photographs.

> *I shutter to think how many people are underexposed and lacking depth in this field.*
>
> —Rick Steves, travel guide and author

Thankfully, this training need not be difficult. Learning only a few tips and tricks will help you get better pictures all the time. By learning just a handful of guidelines, anyone—with practically any camera—

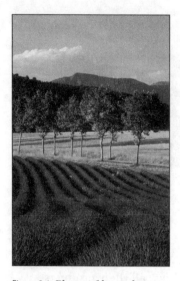

Figure 3.1 Photo of lavender field, road, trees, and sky balancing various graphic elements

can create great photos. This chapter is filled with specific and practical tips to get you going in the right direction. It will give you the building blocks, the core foundation of what you need to know.

We'll dive in by showing you a few ways to transform your average subject into an interesting, artistic composition, where all elements of the picture are carefully balanced with each other.

Because even a perfectly composed picture will fail if it is too dark, too light, or too blurry, we will also discuss ways to consistently capture sharp photos with just the right amount of light and find the best place to have them developed.

Finally, we sum up this chapter with the top ten tips for taking great pictures.

To begin, let's look at the simple ways we can arrange our subjects to immediately start making masterpieces instead of taking mere snapshots. Even if you are totally new to photography and have not yet broken in your new camera, the following primer on composition will teach you how to take great pictures right from the get-go.

 ## COMPOSING YOUR PHOTO

An understanding of composition—the conscious placement of objects in a picture—offers anyone with any camera a simple way to get great shots. If your photos suffer from a serious case of the blahs, use one or more of the following tips to immediately give your photos a boost.

When I first started shooting, I had a difficult time with the notion of composition. I thought, how can I consciously

decide what to include or exclude in the picture? The world, when I viewed it through my camera, looked rigid, unchangeable, and unmovable. It was the real world, after all, rather than some construction of my own imagination that I could shape any way I pleased. Unlike a painter, who can choose to interpret a scene as he likes, I had only cold, hard facts to work with.

> *A good photograph is knowing where to stand.*
> —Ansel Adams

I quickly discovered, however, that I actually could control what goes into the picture. By simply changing my point of view or position, I was able to capture a completely different photo. By moving a little to the left or right—or a little up or down—I aligned objects or made various elements work with each other in a surprising, new way.

As a photographer, you decide what to include in the photo, where to place it, and how much of the picture the subject occupies. More important, you decide what to exclude from the photo. You dictate how the subject of your photo relates to the foreground (whatever is in front of the subject) and to the background (whatever is behind it).

Don't just accept the world as you first see it. Move around . . . experiment . . . explore how you can change each scene right before your eyes.

Deciding upon a Subject: Sacrificing the Good for the Best

Before you begin to arrange things in your photo, first decide what it is that attracts your attention to a particular scene. Defining the subject of your photo is an essential step before you can apply the following rules of composition.

This decision often involves making sacrifices. As much as you may wish to include everything in the picture, selecting one main subject and letting go of the other elements in the scene will help you make it a better composition.

For example, let's say you are taking a picture of your spouse standing in front of a beautiful vista. You can take the standard snapshot, where the natural attractions are off in the distance and your spouse is a tiny figure waving at the camera. If you are feeling photographically adventurous, though, you can think about your scene and make a decision.

If you really want a portrait of your spouse, you might try making her bigger in the picture. Zoom in, walk closer, or have her walk closer to you. If, on the other hand, you come to the conclusion that the view is what you really want to capture as your main subject, then focus all your efforts on that.

Either way, you may have to make a hard decision about what you most want to photograph.

Don't Be Shy; Step Right Up

Once you know your subject, you will find that the most dramatic effect comes from simply moving closer to it. If your subject does not completely fill your photo, the picture will likely include other details that can distract the viewer's attention. Even if no distracting elements surround your subject, blank space can be a problem when your picture has too much of it. Anything competing with your subject

> *If your pictures aren't good enough, you're not close enough.*
>
> —Robert Capa, war photographer

for attention should be eliminated when possible. Filling the frame with your subject is a surefire way to get rid of the competition. See figures 3.2, 3.3, and 3.4, for an example of how you can improve your pictures by getting in closer.

Details, Details, Details

You can take this principle of moving closer one step further. Instead of just getting closer to the overall scene, pick one

detail from it and photograph this detail all by itself.

Have you ever known people who try to fit too many words into one conversation? They seem to convey every detail of a story and, in the process, lose your attention. On the other hand, some

Figure 3.2 Armor on display at Warwick Castle in England. This subject fascinated me, but I knew that the composition was very busy, even muddled and confusing.

choose their words carefully, and, when they speak, people listen. They suggest great depth and meaning by resisting

Figure 3.3 Turning, I noticed this view, which was much cleaner but still had a lot going on around the edges.

Figure 3.4 This final shot turned out the best. By moving in closer, I was able to capture an even simpler and much more effective image.

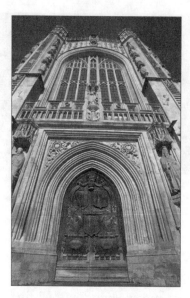

Figure 3.5 Bath Abbey. I liked this façade but was especially attracted to the ladders carved in the stone on each side.

Figure 3.6 Closer shot of carved stone angels. I wanted to get even closer.

Figure 3.7 Detail of carved stone angel. I enjoy this detail shot the most. It reminds me of the entire scene while remaining a simple picture with a lot of symbolic, suggestive meaning.

the urge to share every little aspect of the story. Instead, they focus on only the pertinent details.

In the same way, a photograph that focuses on one well-chosen, interesting detail can evoke strong feelings. By letting go of that urge to "get everything in," you can concentrate on something such as a small, intricate carving,

the talons on a bird, or a child's tiny hand holding her father's pinky finger. By simply suggesting the entire scene instead of actually photographing it, you can take photos that carry a lot more weight.

Figure 3.8 Lion in Bath. Detail of a sculpture photographed on an overcast day.

Moving in closer is an especially helpful trick when the sky is overcast or rainy. By keeping the sky out of the picture, you avoid having a dull background distract your viewer from the main subject. These close-ups will be evenly and softly lit from the overcast sky, instead of being marred because of it.

Tic-Tac-Toe: Using the Rule of Thirds

The Rule of Thirds is an ancient design principle that offers photographers a quick, easy way to add interest and vitality to any picture. Instead of placing your subject in the exact center of your photo, place it a little off to the side. The effect is subtle but amazing; with this trick, you will instantly see a big improvement in your pictures. Here is how it works.

Take any picture and imagine drawing four lines across it. As shown in figure 3.9, draw two lines on the horizontal

Figure 3.9 Picture of railroad tracks, overlaid with diagram of thirds. Placing the tunnel entrance in the upper right axis allows the railroad tracks to lead the eye up to this tunnel.

axis and two lines on the vertical axis, each one-third of the distance from the edge—like a tic-tac-toe game.

When composing your scene, position your subject at one of the four places where these lines cross. Deciding which of the four positions depends largely on what is going on in the rest of the scene. If you notice some distracting telephone wires above your subject, you might want to place the subject on one of the upper two positions, eliminating the telephone wires. If in the upper right of the image you notice an object that could play a nice supporting role to your subject—balancing it out or giving it additional meaning—you might place your subject in the lower left position.

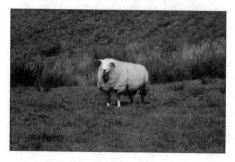

Figure 3.10 Sheep. The "bull's-eye" placement of the subject here makes the picture imbalanced and gives it a slightly humorous feeling. It somehow reminds me of the sheep that say "baa-ram-ewe" in the movie *Babe*.

You can easily see the effect when you compare a photo that has a centered subject with one that utilizes the Rule of Thirds. Photography is not archery; aiming to get your subject in the exact center of your picture is not always the best idea. Simply placing your subject a bit off-center can add an amazing touch of vitality to your photos.

Using this simple rule, your photo albums will soon begin to showcase more interesting, exciting images.

Figure 3.11 Basset Hound. We feel comfortable viewing this photo because we can see where the subject is looking. If the dog had been placed on the left side, looking out of the picture, we'd be less comfortable.

Horizontal vs. Vertical Orientation

Another easy way to make your pictures more interesting is to turn your camera and shoot vertical pictures from time to time.

It sounds simple, and it is. Most people, however, continually shoot pictures in the horizontal, or "landscape," orientation. By occasionally turning the camera and shooting vertical, portrait-style images, you will often eliminate unnecessary clutter and fill your albums with a greater variety of images.

As you look at a potential picture through the viewfinder, decide which shape your subject best fits into: a vertical rectangle or a horizontal rectangle? Each potential photograph tests us to frame it most fittingly. If turning the camera on end and shooting the subject in a vertical orientation eliminates distracting trash in the background, the photo will be much more simple, effective, and beautiful.

At other times, you may find that your subject will fit equally well into horizontal and vertical orientations. One way might tell a different story than the other, perhaps giving a more unique or startling impression of your subject. As long as you are trying both orientations, your collection

Subtle Psychological Tip: Subject Looking into the Scene

If the subject you are photographing is not looking at the camera but rather looking off to one side, consider the following guideline. As figure 3.11 illustrates, the photo will seem more balanced and comfortable if viewers can see what your subject is seeing. By including the area where your subject is looking in the picture, the photo will come across as more peaceful. On the other hand, if you position your subject near the edge, facing outside, the viewer will feel mystery and tension. This same principle also applies to moving subjects. Make sure they are moving *into* the picture if you want people to more comfortably enjoy your photo.

Figure 3.13 North's Cotswold Bakery, horizontal orientation

Figure 3.12 North's Cotswold Bakery, vertical orientation

Helpful Hint

A horizontal photograph connotes a serene, relaxed feeling, whereas a vertical photo comes across as more active or dynamic. Shoot one of each to get a feel for the subtle intonations that your picture's orientation creates.

of images will show a pleasing degree of variety. The best approach of all is to take both a vertical and a horizontal picture of your favorite scenes and decide which one you like best when reviewing the results.

Rolling Off the Edge of the World

Whether you choose a horizontal or a vertical orientation, keeping the horizon level when it shows in the picture is important. You're likely to be disappointed with the prints that come back from the photo lab if you did not keep the camera perfectly level. Even the slightest tilt can distract the viewer from admiring your main subject. When you look at a scene through your camera, take a careful second glance at the edges to make sure the horizon is level.

Having said that, if you did happen to skew the horizon a bit on a photo you love, don't toss it in the garbage can. You can crop the image, trimming off the edges just enough to realign the horizon. If you do not feel comfort-

able doing it yourself, ask a photo lab to crop and realign the image for you.

Scanning the Scene for Distracting Elements

As the saying goes, simplicity is best. When you photograph a scene, be as watchful and selective as you can be and eliminate all distracting elements.

Take a second look just before you press the shutter button. Carefully examine the details around the edges of your view. Take your time, if you can, and scan the scene like the Terminator. If you see anything at all, such as a hair hanging across the subject's face or a slip peeking out from under your subject's dress, stop everything. Fix that element. If you see it in the viewfinder, any flaw is bound to seem huge and distracting in the final image.

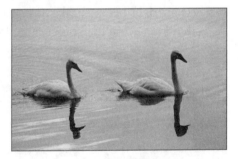

Figure 3.14 Swans with distracting tree branches in the way

This task can become more challenging when, for example, you want to shoot a San Francisco cable car without a single telephone line in the picture. Even in such a difficult case, you have many options, such as these:

Figure 3.15 Same shot after the branches have been removed with the help of a digital image-editing software program

- Move around until you manage to get the telephone lines to make an interesting pattern that leads the eye to the subject.

- Focus in on a close-up detail that "suggests" the whole story.
- Blur the background so only the cable car itself is in sharp focus. To do this, you can use a slower film such as ISO 100 and a longer lens length such as 110mm. Or if your camera lets you, you can select a larger aperture (the size of the hole through which light enters the camera).

For the sake of simplicity, focus on your subject and try to make a concise, bold statement. Remove the clutter to keep it simple.

Getting More Than What You Paid For

The truth about most viewfinders is that they don't show you the entire scene that your film captures. In other words, the printed picture may include more area than what you saw when looking through the viewfinder.

One reason I like shooting with a zoom lens is that I can compensate for this viewfinder problem. I simply zoom in just a hair right before I take any picture. This way, I am assured that I am actually photographing what I intended and not unconsciously including stray elements along the edges.

Fortunately, if you forget to keep this in mind when shooting, you can often fix the problem after the fact. As long as you are using print film rather than slides, you should be able to eliminate the distraction by trimming

Figure 3.16 Although you may only be shown the inner rectangle (marked with a line), your camera may capture the entire scene. You might not have been aware of the two birds in the upper right-hand corner when you snapped the picture.

off the edges or asking the photo lab to crop your picture for you.

Now that you know how to make interesting compositions, it's time to explore a couple more of the basic requirements for any good photo. Learning a little about sharpness and exposure will help you get the most out of your camera, whether you're using a simple automatic or a more complicated manual camera.

Focus is when the majority of the photo (or at least the most important part of the photo) comes out sharp and clear. As you will see, a number of factors affect focus and cause pictures to be sharp or blurry.

Exposure refers to how much light is allowed into the camera. Because film is designed to receive only a certain amount of light, it is kept in the dark until you take the picture. When you do press the button, the lens is generally kept open for only a fraction of a second. When that split second is not timed perfectly, the picture comes out either too dark or too light.

It may not surprise you that people generally prefer photographs that demonstrate sharpness and correct exposure. So let's learn how to consistently give the people what they want.

GOTTA LOOK SHARP

Sharp focus is among the first requirements of a photo. Figuring out how to work with the particular focusing mechanism in your camera is the key challenge. To consistently achieve acceptable focus, you need to learn:

- How to lock your focus before recomposing
- How to know when you are focused
- How to recognize when it's so dark that the picture might come out blurry

With the simplest of point and shoot cameras, you may not have control over any of these factors. If you do, however,

use the following tips and techniques to come away with crystal-clear results more often than not.

Focal Point:
Figuring Out Where to Focus

Sometimes your scene will include so much depth that instead of the entire photo being sharp or blurry, only one point in the picture is sharp, while the rest of the picture is out of focus.

Figure 3.17 Unfortunately, the camera initially focused between the two subjects for this informal portrait. Only the plants in the background are clear.

Figure 3.18 By locking the focus then recomposing back to the original view, the photographer kept her subjects sharp. Photo by Denise Miotke

When this is the case, selecting where to focus becomes crucial. The choice is easy when you know what you want people to look at. Then all you have to do is keep your subject sharp. However, doing this may not be as simple as it sounds.

Because most cameras focus on whatever is in the center of the scene, you will likely need to lock your focus and recompose before you actually take the picture. Your camera may do it differently, but most work something like this:

1. Center your subject and press the shutter button down halfway. Some cameras will give you an indication when the scene is in focus.

2. While holding the button halfway down, move your camera until you have the scene looking just the way you like it.

3. Finish taking the picture by continuing to press the shutter button all the way down.

Check your manual to find out if and how your camera allows you to lock the focus.

At other times, your main effort will be to keep the entire photo sharp. When this is the case, the main trick is to keep the camera steady while taking the picture.

The #1 Cause of Blur
and How to Avoid It

Although a number of factors cause blurry pictures, the most common occurs when the light is not bright enough to allow your camera to take a quick picture. If a lack of light forces the camera to take its sweet time in making the picture (using a slow shutter speed), then the picture is likely to come out blurry.

Definition of Shutter Speed

Shutter speed represents how long the camera takes to make a picture. In our adobe hut metaphor in chapter 1, we could control how much light reaches the film by altering the length of time the shutters were left open. If we were to open and close the shutters quickly, less light would get into the hut and reach the film. This is much like a fast shutter speed used on a camera. Keeping the adobe hut shutters open longer so more light could reach the wall would be similar to using a slow shutter speed on your camera. If we did not close the shutters at the proper moment but left them open a bit too long, this overexposure would likely result in the picture looking washed out or too bright.

Getting Rid of the Jitters: Overcoming Camera Shake

When the camera takes too much time to get a correctly exposed photo, your own flexibility can come between you and a good picture.

Whether you realize it or not, your hands shake a tiny bit whenever you take a picture. They are especially likely to move when you push down a camera's shutter button, even if you think you are holding the camera perfectly steady. This almost unnoticeable, involuntary vibration is called *camera shake*. While experienced photographers work hard to fine-tune their ability to remain stable, even the most firm-footed pros can't help but move a little bit.

This movement is less likely to cause a problem when the conditions are bright. Because the camera takes the picture so quickly, your shakiness will hardly move the camera at all in that split second. When the lighting is a bit dimmer, though, the camera needs more time to take the picture; the longer the exposure, the more likely the camera will move while taking the photo. If either the camera or a subject moves during exposure, a blurry image will be recorded.

If you have no way to view, let alone control, your shutter speed, you can only guess when your camera might select a shutter speed so slow that it will create blurry pictures due to camera shake. It's most likely to occur when you are:

- Using slow speed film
- Shooting indoors without a flash
- Shooting in the evening, when the light is getting dim
- Shooting while zoomed out to the maximum extension

Some cameras will display a symbol when it appears that you are in danger of camera shake. Others will lock up and prohibit you from taking the picture without the flash. Most, however, will rely on you to make the distinction. Therefore, camera owners need to keep a sharp eye out for situations such as those described above.

Regardless of the camera you use, you can try three solutions to avoid the camera-shake problem:

How Film Speed Affects Focus

Using a faster speed of film such as ISO 400 or 800 is a great way to avoid the camera-shake problem. The speed of your film relates to focus because it directly affects your shutter speed. If you use a faster film—one that requires less light to become exposed—your camera will take less time making the picture. Thus the camera-shake problem will be less likely to occur.

- Use a faster film like ISO 400 or 800.
- Use a tripod.
- Make a "human tripod" out of your own body by stabilizing yourself against a wall or resting your elbows on a table.

Shutter speed, while directly relating to the camera-shake problem, plays an even more important part in getting the best exposure.

 ## EXPOSING YOURSELF TO ART: TOO DARK, TOO LIGHT, JUST RIGHT

As film is a light-sensitive material, the more light that hits it, the more exposed it becomes. Each film is designed to only receive a certain amount of light. If too much light is allowed to reach it, film can be ruined in the blink of an eye.

If you have seen the movie *The Godfather*, you might remember the scene at Michael's wedding in which a photographer tries to take a picture of a group of guests. Unfortunately, these guests do not want to have their picture taken. One of the Mafia men opens the photographer's camera and exposes all the film.

Keep Your Camera as Easy to Use as Possible

Finding the simplest way to make your camera work for you is key to getting consistently great results. Feel free to keep your camera set in the "program" mode. If you use an SLR, pick a simple, semiautomatic mode such as aperture priority. Work in this mode most of the time to cut down on the sometimes overwhelming number of decisions you have to make. In this way, you'll be able to control certain basics without letting the other basics control you, and thus keep that 150-page manual where it belongs—in your camera bag.

As long as this doesn't happen to you, and your film stays in the camera, it is in a safe, light-tight place where no uninvited sunlight is allowed to enter. Each frame of the film is carefully and quickly exposed to light when we snap the picture. This exposure usually takes only a fraction of a second and must be extremely precise. If that split second is a little too long, the frame of film will be overexposed. It will get too much light, and the picture will likely turn out too bright. If the split second is too short, the film will be underexposed and the picture will turn out dark or muddy.

Getting proper exposure requires a coordinated effort with your camera. Your camera's meter is a wonderful device, but on occasion it needs a helping hand from you.

Seeing the World Through the Mind of a Minolta (or Nikon or Canon or . . .)

The more we learn about light and the way the world appears on film, the more we will recognize situations in which the camera's meter is likely to be tricked into making an incorrect exposure.

First, it's essential that we realize that film, cameras, and camera lenses do not see the world in the same way our

eyes see the world. Whereas our eyes can usually make out subtle details in the shadows, a camera system will only see black. Our eyes can make sense of the most important parts of a scene, recognizing a wider range of colors and compensating for differences in brightness within each scene.

The typical camera system isn't nearly that sophisticated. First of all, it does not know which to consider the important parts of a scene. When pointed at our spouse and a monument, for example, a camera has to guess that we are most interested in the person standing in front of the monument. Because your camera doesn't have any idea what it should expose for until you tell it, the camera usually settles for exposing on an average of the whole picture. In certain situations, such as an outdoor scene in a snowy environment or an interior with a bright window in the background, this can lead to disastrous results. The fact of the matter is that film "sees" a much more limited range of tones than we do, potentially missing important details in the shadows or highlights of a scene.

This is where you, as the photographer, come in. You have to help this ignorant camera and its even less sophisticated sidekick, film, make the proper choice. As a beginner, you might simply avoid including both extremely dark and extremely light areas in the same scene. That way, you can help keep your camera from making the difficult decisions.

Avoiding Extremes in Contrast

Extremes in contrast can easily fool our camera into making an inaccurate exposure. If, for example, you were photographing your friend standing in front of a bright, beautiful snowfield backlit by the sun, the bright areas would be much lighter than the dark shape of your friend. The contrast in this case would be too extreme. For lack of better information, the camera's meter might assume you were trying to make a pretty landscape photo. For all it knows, the dark blob in the foreground might be a tree stump. If your camera takes in just enough light to make the snowy scene

work, it will likely record too little of your friend. If this happens, your friend will look so obscured in shadows that even the most talented photo lab technician will not be able to save the picture.

Thus it becomes very important to be aware of the main subject you are photographing, especially in a scene with extreme contrasts. Once you learn to notice when parts of a photo might be too bright or too dark, you have won half your battle against extreme contrasts. Aware of the danger, you can recompose your scene until the extremes in contrast are eliminated and you see your subject in a better light.

Another way to help out such a situation is to employ your flash, a topic we will discuss further in the next chapter. First, we will explore how the photofinishing lab can affect the outcome of our photographic efforts, whether your exposures miss the mark or are perfectly correct.

Helpful Hint

Overcast is often great light, but sometimes—because it is actually a lot brighter than it seems—it tricks the camera into underexposing the scene. To prevent this from happening, recompose your scene before you take the picture, eliminating the bright sky from your composition.

CHOOSING AND USING THE BEST PHOTO LAB MONEY CAN BUY

Photo labs are simply places that will take your film, develop it, and make a print of each picture for you. The difference between an average photofinishing lab and a slightly more expensive lab can be phenomenal. You don't even have to go to a professional lab and spend outrageous prices to see a huge improvement in quality, as many affordable labs do a great job.

A Photo Finish

Choose your photo lab with care and resist the urge to simply patronize the lab that has the lowest prices. If you are unsatisfied with your prints, keep in mind that you can find alternatives to the inexpensive wholesale and department store labs. Look for a good, semipro minilab in your area that can give you much better results at prices that are not much higher than you'd pay at a discount establishment.

Find a lab that does developing on-site. Labs that do the work on the premises tend to offer much better customer service than do stores that send the film to be developed elsewhere.

When a photo does not turn out right, compare the print to the negative. Although many picture problems result from improper

Helpful Hint

When selecting a good photo lab, request samples you can look at and ask a lot of questions, such as whether the lab does the processing in-house and whether any lab personnel are photographers. See how they respond to your questions, and trust your gut feeling.

technique or bad cameras, some problems are the fault of the photo lab. For instance, if you see white spots that look like dust or curly lines that look like hair (see figure 6.19 in chapter 6, "Troubleshooting," for an example), they are probably just that—dust and hair that got in the way during the developing and printing process. Take your negatives and prints back to the lab and ask whether they can be fixed.

On the other hand, if your photo looks too light or too dark, determining the cause of the problem is not so clearcut. It could be due to improper exposure on your part or on their part. In such a case, the best solution may be to take the photo and negative into a good lab and ask their professional opinion.

We will get more into analyzing picture problems in chapter 6. In the meantime, know that where you take your film in for developing has a major impact on your photographic results. Paying a few dollars more goes a long way when it comes to making your images look their best.

Now you know everything you need to know to get great pictures–thoughtfully composing your scene, assisting your camera's focus and exposure, and finding the best lab to patronize. Following these suggestions will help you make the most out of your current equipment and photographic opportunities. Let's review.

TOP TEN TIPS FOR TAKING GREAT PICTURES

1. Keep It Simple

When you find yourself about to take a photo, decide what interested you in the scene in the first place and focus all your efforts on getting the best photo of this subject. Instead of trying to squeeze everything into

your picture, be selective, pick your main subject, and let go of everything else. If you really want to include other objects in your photograph, simply take more pictures, with each one focusing on a different detail. A simple composition is bound to be more effective than a busy one.

Figure 3.19 Little lamb. Simple, clean compositions (especially those composed using the Rule of Thirds) will help your viewer enjoy the photo more.

2. Move in Closer

Each time you find yourself taking a picture, move in closer for another shot. Fill more of the frame with your subject. Don't be shy. Even if you think you are close, try moving or zooming in closer. You will be sur-

Figure 3.20 Heidi

Figure 3.21 Heidi closer

prised at how often that tiny viewfinder is tricking you into thinking you are already close enough. By making your subject appear bigger and take up more of the photo, you will eliminate distracting objects on the sidelines and help your viewers better understand and appreciate your picture. If you move in and focus on one detail instead of trying to get a picture of an entire scene, you can often capture more interesting, fresh, and unique views. Such detail photos evoke rich memories by subtly suggesting the whole story rather than trying to tell every detail.

3. **Balance Your Picture and Use the Rule of Thirds**

 Avoid centering every subject you photograph. Instead of simply accepting wherever it happens to land, consciously place your subject wherever it looks best. Try these suggestions:

 - Balance each element in the picture against another.
 - Reposition yourself or your camera until your subject is off-center.
 - Place your subject on one of the axis points created with the Rule of Thirds.

 Although recomposing your photo after locking the focus takes a little more time, this extra step will pay off big. You will find that viewers respond better to pictures that balance major elements with one another.

4. **Take Both Horizontal and Vertical Pictures**

Spice up your photo albums and slide shows with a little variety. Shoot in both the vertical and horizontal orientation. Choose the format that best fits your particular subject. Vertical works well for portraits, and horizontal often does a more effective job when photographing landscapes. Don't stop there, though; with your favorite scenes, take at least one picture in each orientation to see which you like better. Whether photographing vertically or horizontally, remember to keep the horizon as level as you can.

5. **Eliminate Unnecessary Clutter**

If you can, eliminate anything that would distract the viewer from your main subject. The easiest way to do this is to watch your borders and recompose if anything—a telephone wire, a distracting sign, or some kind of debris, for example—is cluttering the picture. Just before you take the picture, scan the scene carefully to make sure that it is free from anything that might distract the viewer from your main subject. If you are taking portraits and realize that the background is distracting, reposition yourself or your subject until you find a background that will give your subject the attention he or she deserves.

6. **Think Like a Camera and Avoid Extremes in Contrast**

Remember that the film and lens cannot see as large a range of color and light as our own eyes can. Analyze each scene before you take a picture. If you notice a large area of bright white as well as an area of dark shadow, one or the other will likely turn out differently on film than you see it. If your subject happens to fall in either the light area or the dark area, it may be rendered almost invisible in the final print. Try moving yourself or your subject around until you eliminate the extremely bright or dark area.

Figure 3.22

Figures 3.22, 3.23, and 3.24 These three photos show a progression of identifying what interested me the most. Once I realized that the shadow of the lamppost was my subject, I could recompose until it became the central element in the picture, making sure all along that I kept it in sharp focus.

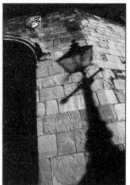

Figure 3.23

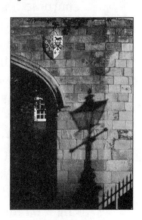

7. Focus on Your Subject

This requires two steps: identifying your subject and controlling your camera's focus mechanism as you recompose. Once you know what the main subject of your photo is,

Figure 3.24

you can work to make this crystal clear to your viewer. With a simple point and shoot camera, locking the focus is usually done by centering your subject, pressing the shutter button halfway down, and then recomposing as you see fit. The 35mm SLRs often work in the same way; the only difference is that they let you see the focusing effect as it is happening. Review your camera manual to learn whether (and how) your particular model allows you to control the focal point.

8. Use the Appropriate Speed of Film

If you consistently see blurry results in your pictures, try using a faster film such as ISO 400 or 800. Totally

automatic point and shoots seem to need this fast film in less than perfectly bright conditions. You can also use a tripod to stabilize your camera; but unless you are able to control shutter speed, you will still be a bit at the mercy of the camera. In such situations, a fast film, even though it will not produce the best quality enlargements, will consistently give you sharper 4" × 6" or 5" × 7" prints.

9. Use the Self-Timer

A self-timer can be used for a much more important purpose than simply taking self-portraits. To help achieve perfect focus, position the camera on a tripod or tabletop and use the self-timer to fire the shot. By removing the possibility of your finger or hands shaking the camera a bit as it shoots, you will get sharper, clearer results, especially in low-light conditions.

10. Work with a Good Photo Lab

Look for an independent, semiprofessional photo mini-lab that is known to give quality results at reasonable prices. Find a lab that does the photofinishing work right on the premises instead of sending the film off to some central facility. When a photo does not turn out right for reasons unknown to you, take it back to the photo lab and ask for their honest advice. If the problem is due to bad developing—and you have selected a photo lab that wants to keep your business—they will offer to do a reprint. If not, they might give you some more good tips on how to shoot the scene better next time.

You are already more than halfway along your path to taking better photographs. With the basics under your belt, you are ready to move on to chapter 4, which will help you master the tricks of the trade, the secrets of professional photographers.

Beyond the Basics: Secrets of Professional Photographers

N ow that you have mastered the basics, you are ready to stretch your wings and soar to new photographic heights.

Like the basics, the following principles are simple. They comprise the tricks of the trade that are shared among professional photographers yet are beneficial to photographers at every level. They can be utilized regardless of the kind of camera you use.

First and foremost, professionals learn to see light in a unique way. They notice color and direction of light. They often rise before dawn to get a head start on the sun so they can make the most of the early morning light. They look for aspects such as shadows and reflections. Additionally, instead of letting trivial factors such as the weather dictate their photo opportunities, they work with even the worst of weather conditions to produce outstanding, dramatic photos.

Surprisingly, professionals often turn *on* their flash when most people would turn it *off*, and turn *off* their flash when

Figure 4.1 Steeple at night with dramatic lighting

others would turn it *on*. You will therefore learn how to get control of your camera flash. Then you'll take a quick look at timing, the art of selecting the best moment to press the shutter button.

The last two tricks most professional photographers live by relate to volume. Professionals recognize that they need to shoot many pictures, taking careful notes along the way. Complementing this, they develop a keen ability to critique their own work so that they end up presenting only their best photographs to others. As the professional learns and practices new techniques, he studies his mistakes so he can take better photos next time.

Let's begin by looking at how the pros look at light.

PAINTING WITH LIGHT

Every great photographer works with a strong understanding of and attention to light, seeing all its various forms and watching it change from one form to another. Light reveals itself with infinite characteristics and subtleties. It can change from bright, cool blue to warm pink in a matter of minutes. When taking portraits, you can do practically anything through a change in light. A soft, even glow can hide wrinkles or when dramatic and directional, light can intensify a subject's weathered features.

The Color of Light

Light comes in many hues, each of which has a profoundly different effect on a photo. The more technical among us describe the various colors of light as different temperatures. For example, candlelight can be expressed as 1,900

kelvins, and noon daylight might be around 5,500 kelvins. Others name the colors of light after the source, simply calling it candlelight or mid-day sun.

It doesn't matter what you call different hues of light, as long as you get in the habit of noticing the various colors. When you do, your pictures will immediately start to improve. Like the professionals, you will be aware of the effect light has on your subjects. You will see how subtle changes in these hues completely transform photos.

Direction of Light

Light can come from many different directions, and it is helpful to consider the direction and angle of light when you take pictures.

When the light source (usually the sun) is behind you and is lighting the part of the subject that you see, this is called *frontlighting*. When the sun is generally in front of you, behind your subject, this is called *backlighting*. Backlighting is much more difficult to shoot and more likely to result in error than is frontlighting. Unless the circumstances do not permit you to reorient yourself, or you are trying to create an interesting effect such as a silhouette, keep the sun at your back as much as possible.

Likewise, light coming from directly above, as when the sun is high in the sky, is not particularly effective light for taking

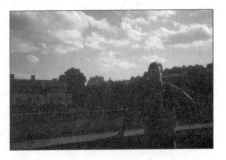

Figure 4.2 Example of backlighting. The subject is obscured in shadows.

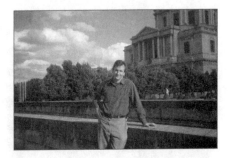

Figure 4.3 The photographer was able to capture a much more successful photo by moving so the sunlight came from behind.

pictures. This overhead light is usually too bright and harsh. It produces no interesting shadows. Objects in this light appear flat and lifeless.

When the light is coming from the side, on the other hand, the three-dimensional depth of the scene is accentuated and the picture looks more interesting. Even slight shadows add drama and give viewers something more enjoyable to look at.

> ## Helpful Hint
>
> For a pleasing portrait of a friend or family member, have your subject stand or sit just inside a door or window. The indirect light there can be very flattering.

Time of Day

A relatively easy way to shoot with both colorful and dramatically directional light is to take most of your pictures at particular times in the day. Just by going out at certain hours, you are bound to take better pictures, and leave those boring picture-taking opportunities for the rest of the world.

All you have to do is either get up early or stay out late so you can shoot when the light is most interesting and at its prettiest. These times give you more than just sunrises and sunsets to shoot. They provide you with a wide variety of potential subjects.

The Early Bird Gets the Worm

If you want the best pictures of the surrounding countryside, go out in the morning. Most professionals generally turn their cameras off around 10:00 A.M., relaxing, eating lunch, reading a book, or taking a nap during the mid-day hours. See figure 4.4 for an example of what you can get when you wake up early enough to shoot in the morning light.

Figure 4.4 Directional morning light shining on little dog

This guideline is not limited to landscape or animal/pet photography; pictures of people also benefit from morning light. The soft, warm light of the morning can cast a very flattering glow on skin tones.

A Late Afternoon with the Camera

During the late afternoon and evening, the light becomes especially warm. With the business of daytime activity subsiding, this may be an even better time to photograph people. More people are bound to be out, and the late light casts a glow much like the morning light.

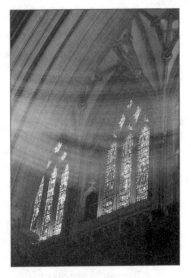

Figure 4.5 Watching the light can result in interesting surprises like this.

If a sunset catches your attention, by all means take a few pictures of it. Once you finish, turn around and look at what the light from the sunset is illuminating. Photographing a person, an animal, or any other scene washed in this light will likely result in a great picture.

Making the Most of Mid-Day Sun

Although the morning and evening are generally best for picture taking, there are great ways to make the mid-day light work as well. If mid-day is the only time you can shoot, try these techniques:

- Move in closer and focus on the details.
- Take advantage of a passing cloud, shooting in its shadow.
- Work in the shade, forcing your flash to fire so it will even out any extremes in contrast.
- Look for the ways that certain subjects, such as leaves in a tree, might be backlit by the bright sun.

- Take advantage of the light for photographing scenes in deep canyons or underwater (only if you have a waterproof camera, of course). Such environments, brightest during the mid-day hours, are often easier to shoot at this time.
- Focus on bold colors that will pop out even more when lit by bright, direct sunlight.

Filters, circular pieces of glass that you place between your lens and your scene, provide another way to deal with mid-day light. Try to turn to filters only when you must, as they do not always create a convincing effect. Used sparingly and appropriately, though, filters can be a big help.

As long as you keep these guidelines in mind, you can still get interesting results when taking pictures from 10:00 A.M. to 2:00 P.M.

Don't Put the Camera Away at Night

Probably the most overlooked and often most rewarding time of the day is long after the sun goes down. By using a tripod or some other method of taking long-exposure pictures without touching the camera, such as a remote control or a self-timer, you can get fascinating new views of normal, everyday scenes. As you might recall from chapter 3, you need to take the picture without actually touching the camera because the slightest movement can cause the photo to turn out blurry. As long as you can make a long exposure in this way, you can create beautiful photographs such as city scenes lit up with twinkling lights (see figures 4.6 and 4.7).

> A day without sunshine is like, you know, night."
>
> —Steve Martin

When painting with light in this way, the last thing the professional would want to do is blast away the delicate balance of tones with an artificial flash. So let's look at how

Figures 4.6 and 4.7 Night and day at the Parliament Buildings in Victoria, British Columbia. The scenes were shot during mid-day and again at night.

you can gain control over your flash and determine when turning it on is best and when turning it off is best.

TO FLASH OR NOT TO FLASH: MAKING IT WORK FOR YOU

Flash can be a great tool when used right. It can enable you to continue to shoot on many occasions. Whether you are taking a few fun snapshots of the kids having their first slumber party or photographing your friends at the beach, a flash can add the light you need, help freeze action, and even tone down extremes in contrast.

Ironically, in dark settings, you must be careful of overdoing your use of flash. It can blast your subject, drowning them in a sea of whiteness, or give off just enough light to illuminate only objects that are far closer than your subject.

To add insult to injury, the tiny flash built into most automatic cameras is generally unfit to do an adequate job. These little guys frequently don't live up to the expectations placed on them. Instead, they give people and pets the red-eye effect, delay exposure until you miss the shot, or trick your camera into taking an improperly exposed, dark picture.

To make the most of your flash, you need to master it. That includes turning it off when you want to. Knowing how to force it to fire, even when it thinks you are crazy to

want more light, is equally important. You should be the one who decides when to use the flash, whether or not the camera deems it necessary at that moment.

Flash On, Flash Off

Surprisingly, a flash often works best in bright, outdoor situations and worst in dim, low-light conditions. Forcing your flash to fire even in bright daylight is a great way to fill shadows. It helps create a consistent, even light across the entire subject.

Thus forced flash gives us a great way to overcome those extremes in contrast that we discussed in the last chapter. By lighting the objects in the shadows so they appear as bright as the objects in the sunlight, the film can more easily render the entire scene. This *fill flash* (another way to say "forcing it on") is a great way to eliminate dark shadows in a person's eye sockets, to slightly illuminate subjects that are lit from behind, and to give your scene added crispness and color.

Another benefit of using fill flash is that when taking pictures of people or animals, it will produce a small catchlight

Figure 4.8 Portrait taken in the evening without flash

Figure 4.9 Second portrait using fill flash

in the subject's eyes. This little sparkle will add a nice touch of vitality.

No Flash Allowed

The ability to turn off the flash can also come in handy. When you know that the blast of light won't reach your subject, when you prefer to make the most of the natural light, or when using flash is considered rude or against the rules, turning off your flash is a good idea. In an intimate setting like a nightclub, for example, where flash can be distracting to the performers, it is usually prohibited. Using a fast film, stabilizing your camera, and taking advantage of the available stage light would likely result in better pictures.

Being able to force the flash on or off is a feature offered in many cameras. The function is usually represented with a little lightning bolt symbol on the LED display or on the camera body. Check your manual to see how to use fill flash and how to turn the flash function on and off.

Helpful Hint

Try turning the flash on even when photographing people in bright, outdoor conditions. One reason is that bright light coming from behind your subject can cause extremes in contrast that film cannot successfully capture. Forcing your flash to fire by overriding the automatic settings will help counteract such extremes in contrast and fill in shadows.

Off in the Distance: Flash Fall-Off

Flash can only go so far before it becomes ineffective. It works best when your subject is relatively close to your camera. If you shoot from too great a distance, the flash will not reach its intended subject and thus be unable to accomplish its purpose.

At the opening ceremonies of the Olympics, for example, thousands of spectators take pictures with the flash on. For those of us watching on TV, this makes a very pretty display; the little lights flashing in the crowd cause the stadium to

sparkle and glitter. However, for those shooting, even from the closest seats, there is little likelihood that their flash is having the intended effect. Only the backs of the heads of people sitting in front of the photographer will be lit. One solution in this situation would be to use a faster film. Another might be to use a tripod, allowing the light from the show to expose the film without help from the flash.

Au Natural: Flash vs. Using Natural Light

You might notice that the flash often produces an unnatural effect. The light is flat and harsh and frequently makes people appear pale and washed out. Sometimes this is the only light you have to work with. If using natural light is at all possible, you will find it creates a much softer, more pleasing look.

Figure 4.10 In this case, indirect open shade helped create a soft, pleasing portrait of this couple.

When you're taking a portrait of a person, for example, using a nice, soft natural light will create a much more flattering effect than will a flash. A bright, overcast day works especially well in this case. This is one reason you should never forego a photo op just because the sky is cloudy and overcast. As we will explore in a moment, professionals find ways to use any lighting conditions to their advantage to make great photographs.

For the time being, the key is to think about the effect the flash will likely have. As you shoot, you will develop a keener ability to guess how the scene will look one way or the other. Whenever you have the slightest doubt, feel free to shoot the scene both with and without flash, choosing the best after reviewing the results.

 # WORKING WITH WHATEVER WEATHER YOU'RE GIVEN

The pro never lets slight changes in the weather stop him from taking great photos. In fact, some actively seek out interesting weather conditions to add extra vitality and excitement to their photographs.

It is true that keeping your camera from getting wet is generally a good idea. When shooting in slightly misty conditions, wrap your camera in a shower cap to protect it from mist and rain. As soon as you are ready to take a picture, remove the plastic cap, quickly shoot the photo, and wipe off any water before putting the cap back on. Caveat from my lawyers: By getting your camera wet, you risk ruining it;

> ## Helpful Hint
> Use the overcast sky to your advantage. Simply exclude the sky itself from your composition and instead use its soft light to indirectly illuminate your subject. This light can make great portraits of friends and family and help you turn these dimmer days into photographic gold mines.

forego activity that will result in wet equipment if you are concerned about damaging your camera. Because I am the kind of guy who likes to live on the edge, I'm willing to risk a damp camera to get a good shot.

All the same, you don't necessarily have to put your camera in danger to get great all-weather photos. You can:

- Buy a waterproof camera.
- Keep yourself in a protected place while shooting such scenes.
- Or perhaps get a protective case designed especially for your camera.

The rewards of shooting in such weather include being blessed from time to time with a dramatic array of light

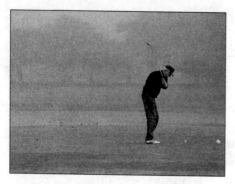

Figure 4.11 Even though the day did not look like a good one to be out taking pictures, this photo of a golfer actually works better because of the heavy fog. The fog obscures the background just enough to make the scene more interesting.

breaking through the clouds or an especially colorful moment like a rainbow. By taking advantage of these unusual elements, you get to paint your scene with more than just color; you can use a variety of textures, forms, and patterns.

Whatever kind of weather comes your way, try not to let it prevent you from taking great pictures. Working with the weather has a lot to do with timing things just right, with getting yourself into position so you can click the shutter at exactly the right moment.

You will recall in the last chapter, we discussed the importance of taking a long, careful look at each scene to make sure no distracting elements show up in your picture. We stressed the need to remove any clutter in an effort to keep your composition clean and simple.

> Sometimes I do get to places just when God's ready to have somebody click the shutter.
>
> —Ansel Adams

Sometimes, though, taking a minute to make sure everything is correct can mean missing the photo altogether. Having no photo is usually worse than having a poorly composed picture. After all, if you miss the shot entirely, you probably won't be able to re-shoot the exact same picture again. For that reason, we'll now consider a few tips and tricks on timing.

TIMING: CATCHING THE DECISIVE MOMENT

Photographs are frozen moments in time as well as representations of a particular place. In a fraction of a second, one scene can change into something completely different. When photographing natural landscapes or travel images, a passing cloud can instantly turn your scene into a dark, dull view. Every moment offers a different picture.

Shoot First; Ask Questions Later

As I mentioned earlier, scanning the scene for distracting elements is wise—when you have the time. All too often, though, a photo opportunity is gone before you know it. That's why a good trick is to take a quick picture before even thinking about how to best shoot the photo. By taking the initial shot, you'll at least have *something* on record.

Especially if your subject is not static—if it can move at a moment's notice—take one shot before you even consider ways you might compose the scene. Taking such a "safety shot" has given me many decent photographs of birds, children, and other fast-moving subjects. Before they fly off into the sunset or run away, I make at least one quick exposure. I may prefer a better, closer composition, but I am happy to have at least one photo of the subject in my collection.

 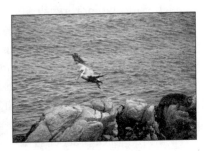

Figures 4.12 and 4.13 Pelican on rock and in flight. Scenes can change in the blink of an eye.

Don't let the photo op disappear while you are figuring out a better way to shoot it. By being quick to the draw, you can remove any worries, thus allowing yourself to concentrate on making the next shots as perfect and interesting as you can.

Patience Pays Off

After you get your one quick safety shot, being as slow as molasses can pay off. Shoot a bunch of images and then, after you think you have taken all the pictures you need, wait around for a few moments. Conditions change, people walk by, and clouds blow off, letting the light hit your subject just right. If you are taking portraits, your subject might suddenly feel relaxed and smile with great warmth. You never know what the next few minutes will bring.

Anticipating the Moment and Dealing with the Dreaded Delay

Many cameras do not take the picture immediately when you press down the shutter button. The delay between the moment you press the button and the moment the camera actually takes the picture can cause you to miss the shot—and get frustrated in the process.

If you experience this problem, the best solution is to anticipate the moment and learn to take pictures before they actually happen. If a motorcycle is driving by, for example, you may have to press the shutter button a second or two before the motorcycle reaches optimal position.

To maximize the likelihood of catching the shot, you may be able to prefocus your camera. Press down the shutter button halfway to lock the focus before shooting. If the subject is moving too fast, try prefocusing on something that is the same distance as your subject will be when you take the picture.

Good timing is a developed talent and can only be mastered with a lot of practice. The only other way to deal with the timing problem is to take lots and lots of pictures, hoping that at least one will catch your subject at just the right moment.

SO MANY PICTURES, SO LITTLE TIME

Probably the most helpful tip I can give you is this: Carry your camera with you everywhere you go. It's as simple as that. Every moment is a picture opportunity. If your daughter is getting her ears pierced, take along the camera. Taking the dog for a walk down to the park? Take the camera!

You never can tell what scenes will present themselves until they unfold right before your eyes. Don't let anything—inconvenience, embarrassment, or plain old forgetfulness—stop you from bringing your camera along with you. The professional knows that the key to getting great photos is to take a multitude of pictures. A great exercise is to repeatedly shoot the same subject—whether it's your cat, flowers in your garden, your friend, or someone in your family. By concentrating your efforts and practicing on one subject, you will master the basics much more rapidly.

> ### Helpful Hint
> Carry your camera with you everywhere you go. Even if you just try this for a few days, taking the camera with you to and from work, you will be surprised at how many opportunities present themselves to you.

Albums and Albums of Photos ... with a Pinch of Variety

Although the idea here is to get as many pictures as you possibly can, that doesn't mean ordering double prints or leaving your camera in the "continuous shooting," motor-drive mode. Most photographers don't want pictures that look exactly the same.

Instead, the best method is to make the most of each moment while it is happening, balancing the large number of photos you take with a variety of techniques, angles, and positions. Do-overs are next to unknown in photography; you can rarely go back and shoot again after the moment

Fun Fact!

A famous photographer used to assign people the project of shooting the same subject every day for a few months. Jeff Bezos, founder of Amazon.com, shoots at least one snapshot a day. Harvey Keitel, in the movie *Smoke*, plays a man who takes one photograph from the same street corner every day. Shooting the same subject or scene repeatedly is an excellent way to quickly become a great photographer.

has passed. Therefore, the key is to shoot a lot and make many different images while you are at the scene.

One benefit of shooting so much, as we will see later, is that you will have so many more to choose from. Skimping on shots because you fear the expense of film and developing is a surefire way to fail to get the kind of photos you want. Refuse to be ashamed by the fact that you take lots of pictures; be proud of it!

Repeat This Mantra: "Film Is Cheap!"

How much does it cost to go on a trip? How much is your time worth when you drive up into the mountains for a day or two? Film is so inexpensive and developing is cheap compared to the expense (or impossibility) of attempting a re-shoot.

Don't worry about wastage. The law of numbers demands that you take as many pictures as you can. If you get eight to ten good shots from a roll of thirty-six, congratulate yourself on a job well done. Even the pros have to shoot a lot to get a good amount of satisfying photos.

If you can't help but be concerned about the expense, and you use print film, here's a way you can save a little money: If you have finished

Helpful Hint

Shoot as often as you can. Don't worry about looking silly; what other people think about you is none of your business. Just get out there and take pictures as often as you can.

shooting your subject and want to take your film to the lab right away, don't shoot off the rest of the roll just to use it up. Having these extra photos developed and printed adds unnecessarily to your bill. Contrary to what you might think, wasting a bit of film can actually be more economical than using it all up.

Figure 4.15 It is an especially good idea to take as many pictures as you can when photographing children.

A Portrait for Every Person

Figure 4.14

Volume can come in especially handy when you're shooting group portraits. The general rule that has always worked for me is to shoot as many shots of a group as there are people in the group. If you are photographing a family of five, take at least five pictures of the group.

No matter how good you are, and no matter how well everybody in the picture is behaving, one person will likely be doing something distracting. Someone might be staring off to the side in one shot while someone else's eyes are closed in another. By taking as many shots of the group as you can, you are bound to get one in which everyone is in sync, looking at the camera, and smiling naturally.

When you do have to take many exposures, work quickly. You have only a short window of opportunity before subjects get bored or the sun begins to set. Balance the number of photos you need with thoughtfulness and consideration.

Note Taking

Another helpful item to carry around, in addition to your camera and a spare roll of film, is a notebook. When you can, take time after each shot to jot down the settings you

used to take the picture. Note any unusual aspects, such as what you were trying to achieve or how you were trying to achieve it. If you have the names of the places, people, or things you are photographing at hand, write them down in your notebook. Trust me, if you don't write it down, you will probably forget the details by the time you get the pictures back.

> *Notebook. No photographer should be without one!*
> —Ansel Adams

These notes will come in handy when you critique or caption your photos. They will save a lot of time you might otherwise waste trying to figure out what subjects are actually called. Most importantly, your notes will help you learn at an accelerated rate.

PUTTING YOUR BEST FOOT FORWARD

Taking a lot of pictures is only half the battle. The second stage, selecting the best of your photos, is an equally important step to putting together a collection of great pictures.

Separating the Chaff from the Wheat

It is true that to get great photos you simply have to take a ton of pictures. If you take this plethora of pictures, though, and leave it at that, you will get bogged down in the results. Sort through your pictures and weed out the bad ones; otherwise, you will be constantly looking at many, many rejects and only a few winners. After a while, you might begin to think of yourself as a bad photographer. That's one reason why selecting your best work is so crucial.

So go ahead and take a bunch of pictures of the same subject; just don't let anyone other than yourself see *all* of them. Weed out bad pictures right away. After you have thrown away the totally blurry shots, the black photos, and the really, really boring ones, go through the remaining photos again and separate out any mediocre shots. Put

these mediocre images in something such as a shoebox, then go through the remaining photos yet again. This time, set aside any photos you think are only personally interesting. Put these into your personal album or another container of some sort.

He Shoots, He Scores

Finally, all your hard work has paid off. After you have placed the personal snapshots in their appropriate album or container, you will be left with only the real winners, the crème de la crème. These are the images you'll want your friends and family to see. Make the most of them.

> ## Helpful Hint
>
> To make the strongest impact with your photos, select your best work before showing it to others. It is so simple and yet so incredibly effective. Presenting just a few of your best shots makes you look like a photographic genius.

Place them in special presentation portfolios or get enlargements to frame up and hang on the wall. This is your gold; cherish it and share it with as many people as you can.

As You Select, Be Objective

As you work your way though the selecting process, the key is to look at each photo with as much detachment as you can. Watch the details; if a shot shows some distracting elements, put it in the "Questionable" bin instead of placing it with the crème de la crème. Pay special attention to thoughts such as "I almost had it with this shot. . . ." The word *almost* is a dead giveaway that the shot is questionable. Although the picture might still make the grade, you should be ready and willing to weed it out if need be.

Be especially objective when it comes to overdone subjects such as flowers, sunsets, and the like. These are great subjects to shoot, but when it comes to making your selections, keep in mind that such subjects have been photographed so frequently that the standard of excellence is exceptionally high for them. Whereas a mediocre photo of

an unusual subject such as Bigfoot or the Loch Ness Monster might win awards just because the subject is so rare, your collection of sunset or flower photos will probably benefit from extra shaving off the top. You only want people to see what they will consider the upper crust of all photos they have seen.

Always Leave Them Wanting More

I hate to be the one to tell you, but most people do not care to see every angle of your bouncing baby boy. One or two great shots will do the trick. When you show only the best, people will think you are a great photographer. The next time they visit, they will be eager to see a few more—and might even ask you to take pictures of their own bouncing baby boy. What an honor!

In the Long Run, Less Is More

A surprising thing happens as you work your way through a big batch of photos. The first pass you make, you feel terrible. Thoughts such as "How could I have shot so much junk?" or "What is wrong with me?" might plague you. Then by the third or fourth pass, if you are still at it, you experience a change of heart. When nothing but your best images remain, you actually feel great about what you photographed. Amazingly, you forget all the bad pictures you took. Getting to this encouraging point is an important part of any artist's growth. Besides that, it feels great!

Image Being Everything

As much as you might feel tempted to drag your heels when it comes to weeding out your bad photos, this process will do more for your image as a photographer than any other. It will help others see you as a talented shooter. Each time you put your best foot forward, you will develop a stronger and stronger image of yourself, and this will likely encourage you to shoot even more great images.

Remember, slide shows don't have to be boring and albums can be pure works of art. You certainly don't want people to think that your good shots are a fluke, the result of a little luck. Show only the best few choice photos of your record-breaking steelhead trout or your adorable kitty, and you'll be viewed as an expert photographer.

> *If that's what they cut out, what they leave in must be pure gold!*
> —Troy McClure, narrating the *Simpson's Outtakes*

 ## LEARNING FROM YOUR MISTAKES

In addition to making you look like a better photographer, this careful review of all results—both good and bad—is essential to learning. The student of photography who analyzes his or her work will be the one who becomes excellent more quickly. Dealing with the aftermath is where all your hard work taking notes pays off big time.

Throwing Mud on the Wall: The Shotgun Approach

Continually shooting one group of pictures after another without thinking about the technique you use is like throwing mud against the wall to see how much of it will stick. The gears spin and the photos are produced, but progress and improvement moves at an incredibly slow pace, if at all.

The solution is simple: Study your results.

Studying the Results

Compare each photo with the notes you took at the time of shooting. Ask yourself if you achieved your intended purpose. Think about the settings and techniques you used. If the shot was successful, make a note that the particular technique used in that situation worked. More important, perhaps, is to note your failures and to try to figure out what

went wrong. Analyzing your mistakes will give you ideas on ways to shoot differently. If you are not sure why the photo did not turn out as you expected, consult chapter 6, "Trouble-shooting: Solutions to Common Photo Problems," or ask someone at a good photofinishing lab for their opinion. Alternatively, ask a friend or post the photo on a Web site and request a critique from your peers.

However you do it, return to your mistakes and study them. Thinking about how you might do it differently next time will help you become a better photographer in the shortest amount of time.

TOP TEN TRICKS OF THE TRADE

This chapter covered a lot of ground, which is summarized in the following top ten tips. Review all these principles, and you'll be ready to put them into practice by doing some of the helpful photo assignments provided in the next chapter.

1. Look at the Light

When you survey a scene, don't just see the subjects but also notice the quality of light. Be aware of the color, angle, and intensity of the light you are working with. Which way are the shadows falling? Is the light a particular tone (bluish, warm)? How is the light affecting your subject? Is your subject squinting? Unless you want a silhouette effect, with your subject a dark shape against a bright background, it's generally best to shoot with the sun behind you. This works especially well if you are in love with the bold colors in your subject. Side lighting, on the other hand, can add drama but can also cause extreme, hard-to-print contrasts. Lastly, use indirect, overcast light to make your subject glow soft and pretty.

2. Go Out Early; Come Home Late

While you can get great pictures any time of the day, early morning and late afternoon offer the most inter-

esting, unusual, and beautiful light. Shadows add depth and drama to scenes. Angular morning and evening light washes subjects in a warm glow. Streets are often free of crowds. Animals are likely to be feeding rather than sleeping. The edges of the day are often the most exciting to photograph. If you are traveling and the weather is good, consider skipping your morning meal to go out shooting. Visit the museums and indoor events during the day. Keep your mornings and late afternoons open for picture-taking time.

3. **Turn On Your Flash in Bright Daylight**
 Even in bright sunlight, filling shadows with your flash is a great way to reduce the range of contrast and produce more pleasing pictures. It is also an excellent way to create catchlights in the eyes when photographing people or animals. Force it on even when shooting in the daylight, and you will notice a nice improvement in your pictures.

4. **Use a Tripod and/or Fast Film Instead of Your Flash**
 In low light conditions, consider turning your flash off so that it does not fire. Instead, use a tripod and try to make the most of the available light. Rely less on your flash in low light to keep your pictures looking natural and beautiful. If using a tripod is impractical, such as in a crowded concert or sports arena, use a fast speed film to take advantage of the available light.

5. **Use Overcast Days to Your Advantage**
 Instead of staying indoors on dull days, use the soft light to make evenly lit pictures. If you want to photograph

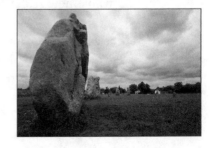

Figure 4.16 Avebury, England, on an overcast day

landscapes and scenics, simply keep the dull sky out of your pictures as much as possible. Or perhaps you can use the cloudy sky to add a bit of texture and drama to your photos. Alternatively, shoot portraits of a friend or family member. The soft light will be especially gentle and flattering.

Work with the weather; don't allow it to stop you. When the day is beautiful, go ahead and make the most of it. If not, find ways to use the bad weather to your advantage.

6. Anticipate the Moment and Be as Quick as You Can
If your subject may fly away, stop smiling, or just get tired of waiting for you to take the picture, shoot one "safety photo" right away. Practice getting quicker and quicker to the draw. Don't worry about wasting film, and don't wait until you're absolutely certain all the knobs and buttons are in their correct position; these are surefire ways to miss the best shots. Shoot first, ask questions later.

7. Wait Around for a Change in the Scenery
Even after you have shot your subject in a variety of different ways, hang around for a few minutes. Wait and watch to see how the light or any other aspect of your photo changes. By being patient and enjoying the view for a few moments longer, you open yourself up to a whole new realm of picture-taking opportunities.

8. Shoot as Much as You Can
Take your camera with you everywhere you go. Do not leave home without it, and never worry about wasting film. Remember the mantra: "Film is cheap." When shooting group portraits, take as many pictures as there are people in your photo. As much as you might think that the best photographers take only a few

shots, they take many; we only think they take few photos because all they ever show us is their best.

9. **Edit Your Way to the Crème de la Crème**
 Withhold your bad pictures from everyone except those who might be able to help you improve. As much as you might feel that all that film and developing was wasted, you will be greatly rewarded by putting the losers into a shoebox and stashing it in the closet. When others see only your best photos, you gain and benefit from the status of an expert photographer.

10. **Take Notes and Study the Results**
 Taking notes is essential to learning how to improve. If you never sit down and look over your notes to help you recall what exactly you were trying to do, you will learn at a much slower pace. Compare your shooting notes to the resulting photos to see if you came close to reaching your photographic goals. If you did, congratulation yourself and write down what worked so you know next time. Likewise, try to figure out why the failures happened and write down ideas you have for improving. In this way, before you know it you will be shooting masterpieces more often than not.

Now that you have read all about the basics and secrets of professional photographers, commit them to memory and make them second nature. The next chapter gives you a few projects to help you do just that. So let's start mastering these principles by putting them into practice.

Putting It into Practice: 20 Step-by-Step Projects

Photography is a practical art. Even if we discussed it for days and days, you would not learn as much as you would by complementing your studies with practice, getting out there and taking pictures yourself.

By itself, though, learning experientially can be frustrating and expensive. The school-of-hard-knocks method makes it all too easy to become immobilized, unable to figure out what to shoot or how to proceed.

> *I hear and I forget.*
> *I see and I remember.*
> *I do and I understand.*
>
> —Confucius

So we will focus our efforts on shooting a set of inspiring and practical assignments. In this chapter, only the projects that teach valuable principles have made the cut. These projects can be done with almost any camera, whether simple or sophisticated.

Each project starts with a list of any items you will need in addition to your camera, a summary of the subjects involved, and a few notes about the principles you'll be prac-

ticing. If the project includes a degree of flexibility, a summary of options is also included.

By completing these projects, you'll learn the main principles of photography first-hand. You'll master the tips and shooting techniques. On top of that, you'll have fun. After all, in the field—when you're out shooting pictures—is where the real joy of photography takes place.

Now that you've paid your dues and learned the basics (as well as a few tricks of the trade), it's time to put those principles into practice. So if you haven't already, let's get out there and start actually taking pictures.

1. The Sun Also Sets

Ingredients:	Tripod or a fast film
Subject:	What the sun illuminates as well as the sun itself
Principles:	Going out early; coming home late; analyzing the color of light; facing the light vs. turning so the sun is at your back; noticing and using the direction of light; avoiding extremes in contrast; keeping your compositions simple

1. Get up early (this may be the hardest part).

2. Go to your favorite vista and shoot a bunch of pictures just as the sun is rising. In addition to pointing your camera at the sunrise, turn around and shoot in the opposite direction. Don't just shoot the sunrise; use its light to illuminate your scene. Notice how the

> ### Helpful Hint
> For better sunset photos, try focusing on a detail like a boat in the harbor. Or turn around and capture the light as reflected in the face of a friend, leaving the sunset itself entirely out of the picture.

light affects the coloring of your subject, whether you're shooting a person, landscape, or other scene.

3. Revisit the same spot around lunchtime and try to duplicate the photos you took earlier.

4. Repeat the previous step one last time in the late afternoon or early evening, at sunset.

5. When you get your pictures developed, compare the various results. You will be amazed at how much the scene changes throughout the day. The shadows fall in different places, and the color of light becomes dramatically different. The early morning and late afternoon sun washes everything in a pleasing warm tone, and the side lighting adds three-dimensional depth to the scene.

 After doing this project, you will see why professional photographers call these times the "magic hours."

2. Flower Power

Ingredients: A camera lens that allows you to get close
Subject: Flowers
Options: Interesting plant, bug, or other low-to-the-ground object
Principles: The psychological effects of changing your point of view; keeping your composition simple

1. Find out, if possible, how close your camera lens allows you to get to your subject before it loses the ability to focus clearly. If you have a 35mm SLR, you will likely notice the camera not focusing properly when you are too close. If you have a point and shoot, you will have to peek at the manual; the problem might not rear its ugly head when you are looking at the scene through your viewfinder. You will, however, see it when you get the prints back from the lab.

2. Once you know how close you can get, go look for the perfect flower (or other low subject). Once you find one, take a few pictures at various angles while standing above it.

3. Get as low as you can to the ground. Crouch down or, better yet, lie down and look up at it, as much as the situation permits. Move around and look through your viewfinder from various positions. Watch how each change affects the look of your flower and whatever is in the background. Compose your picture so that any objects in the background do not interfere with the flower. Try to give your flower the even-toned, nondistracting background it deserves. Each time you find an interesting composition, take a picture.

> ## Helpful Hint
>
> Add an element of interest to your flower shots by lightly misting them with water before you shoot. You can carry a small spray bottle for this purpose. If you feel something is missing as you stare at a flower through the lens, use your spray bottle and add a nice touch.

4. After picking up your pictures from the photo lab, sit down and compare each photo. As you study them, decide which best shows off your subject. Which one makes it look most impressive? Which one pops off the page? You will find that the photos of such subjects shot from extremely low angles can be most unusual and appealing.

3. Surveying the Landscape

Ingredients: Tripod; slow speed film
Subject: Mountains, valleys, lakes, streams, forests, barns, bridges . . . you get the picture
Options: Cityscapes and/or seascapes
Principles: Getting a level horizon; using graphic shapes and lines to your advantage; avoiding

Figure 5.1 Vineyards with the French village of Jarnoix in the background

extremes in contrast; keeping your composition simple

With this project, we are going to head out into nature, to the sea, or to a nearby city to capture a prize-winning landscape photograph.

1. Get the slowest speed film your camera can handle. If you have a tripod, you can use a roll of Fuji Velvia (ISO 50) slide film or Kodak's Royal Gold 100 for a print film. If not, a 400-speed would be fine.

2. Pick an area you would like to explore on a grand scenic level. If you live near a national park (lucky you!), then head in that direction. Large cities with lots of skyscrapers make good material for the urban dwellers among us. Photographers who can get to the coast might prefer to focus on the sea. Don't worry if you don't live anywhere near a park, city, or sea; you can make great landscapes almost anywhere.

3. Study the light. If you can get to your chosen place in the early morning (before sunrise), do so. As mentioned in the project on sunrises and sunsets, the best times to shoot are generally before 10:00 A.M. and then again just before the sun sets.

4. Once you decide on your subject, then compose your scene, paying careful attention to graphic elements such as lines, shapes, and forms. Look for interesting shadows and reflections. Try to make all elements lead the eye in a satisfying way. If you are drawn to a par-

ticular tree or peak on the horizon, align yourself so that a road or river leads up to that subject.

Option: Take a few pictures of a view that is partially in the sunlight and partially in the shade. Then take a few more with the entire scene in shade. Finally, shoot again, only including things that are in direct sunlight. When you get your prints, compare the results, and you will see how poorly extremes in contrast translate on film; either the shady area will be too dark or the highlights too light.

> ## Helpful Hint
>
> Before shooting, drive or walk around the area you plan to photograph. Try to imagine what the light will be like during your shooting time. Preparing yourself in this manner will not take any of the fun out of photography and will only make your results better.

4. Moving in for a Detail Shot

Ingredients: A long tele-
 photo or zoom lens will help.
Subject: A detail
Principles: Moving in closer; simplifying your composi-
 tion; removing clutter; seeing things in a
 creative, new way

Figure 5.2 Standard photo of typewriter

Figure 5.3 Close-up detail shot of typewriter

This project works when you are photographing anything, whether a barn, a church, a cityscape, a field of flowers . . . you name it.

1. When viewing a scene, select one interesting detail that captures the essence of your scene. For example, a fire hose or ladder might be all that you need to photograph to successfully "suggest" the entire fire truck.

2. Once you pick a subject, focus all your photographic energies on capturing it in an unusual way. Move in closer and fill your frame with this detail.

3. Try shooting your subject in a vertical "portrait" orientation as well as in a horizontal "landscape" orientation.

4. Push yourself to continue moving in closer and trying to see new views of the subject. Get so close that the detail itself is only partially captured in your view.

5. If you feel equally attracted to other subjects in your overall scene, repeat these steps with that detail.

The point of this project has less to do with macro, close-up photography and more to do with conceptualizing how one small part of an overall scene will work as its own picture. Try to especially do this from time to time when you are traveling; the results will come to play a big part in your overall memories of the trip.

5. Self-Portrait

Ingredients:	A tripod makes it easier; a prop makes it more fun.
Subject:	Yourself
Options:	Including a prop, pet, or other loved one
Principles:	Previsualizing

Anyone can do this project because everyone has this particular subject so close at hand.

1. Pick a place to take a picture of yourself. Choose a background that is the least distracting. Green bushes and trees can provide a great backdrop. A location in indirect light, such as shooting in open shade, can provide a complimentary look.

2. Once you find such a location, mark a place for you to stand several feet away from your background. This will increase the likelihood of the background showing up blurry while you remain sharp in the print.

> ## Helpful Hint
> When shooting any kind of portrait, pay close attention to the background. If you have a choice, select one that is nondistracting. Choose a background color that contrasts well with your subject to help make it stand out. Your goal is to focus all the attention on your subject without allowing anything to compete for the viewer's eye.

3. Set up your camera on a tripod. If no tripod is available, prop up your camera on a tabletop or chair.

4. As you set up the camera, note the area that you will be capturing in the viewfinder. If you need to, adjust the camera so that it is aiming in the direction you will be photographing. If you need to raise the camera, increase the height of your tripod. If you lack a tripod, you can use a stack of telephone books or whatever works to raise your camera.

5. If it looks like you will not be in the center of your scene, you will need to preset and lock your focus before shooting.

6. Force your flash on to provide a nice fill-flash as well as a catchlight in your eyes.

7. Set the self-timer mode or use a remote control to begin the countdown process.

8. Quickly position yourself in your predefined spot, smile, and wait for the camera to flash.

Option: Include something you love in the photo. If you are a musician, perhaps you would like a self-portrait with your instrument. If you are attached to your pet, invite him or her into the picture. Be forewarned, of course, that your pet might not want to have its picture taken. If this is the case, look at the project "Pet Portrait" for many helpful tips. If that does not work, consider doing this with a human friend instead. (Your friend may not want to have his or her picture taken either, but at least you might be able to talk a human into it!)

6. Family Portrait

Ingredients: A group of willing subjects
Subject: Your family
Options: Another group of three or more people
Principles: Managing a group of subjects; avoiding extremes in contrast; being the master of your flash; taking a second pass before you take the picture, paying very close attention to the details to make sure nothing distracting remains in the photo

As a great way to learn about shooting as many shots as you can, try doing this family or group portrait.

1. Set up your location before getting any of the subjects involved. When finding a location, look for a simple,

nondistracting background in even, indirect light. Avoid dappled light as this will create extremes in contrast that your camera and film cannot handle well.

2. Set your camera up on a tripod, if you have one.

3. Invite the people in and let them arrange themselves. If they ask for your expert advice, just make sure nobody is getting blocked; if necessary, arrange people so that you can clearly see everyone's face. Also watch out for individuals who are uncomfortably straining around someone else to be in view of the camera. Arranging the taller people in the back will help.

4. Most important at this point is to encourage and help your subjects feel comfortable. If humor comes naturally for you, use it to overcome resistance and make people feel more at home. Telling the group that they look great can be more effective than endlessly shuffling them in an effort to get your perfect composition. In this situation, your friendliness, consideration, and politeness will play as significant a role as your photographic skill and technique.

Helpful Hint

To reduce or eliminate glare from a subject's eyeglasses when you're doing portraiture, simply tilt the glasses so they are at a slight angle. This prevents the glasses from reflecting light from your flash directly back into your lens.

5. Scan the scene for any distracting details. Are any stray hairs in your subject's face? Any clowns doing bunny ears? If you see glasses that might create obscuring glare over someone's eyes, ask whether the person might prefer to take them off, or tilt them as suggested in the sidebar. Most important, check to make sure everyone is looking at the

camera. This can be a particularly big problem when more than one photographer is present.

6. Once the group is arranged and ready to go, make sure your camera is focusing and exposing properly. Put your finger on the shutter button, talking casually (and genuinely) to the group while you wait for the perfect moment—when everyone looks relaxed and natural. This juggling act will come most easily to those who can do two or more things at once.

7. Shoot as many pictures as there are people in the photo. If you have an extremely large group, shoot as many photos as you can get away with before they start getting impatient. This is the best way to overcome the fact that you won't be able to predict when people blink, yawn, make a strange face, or look off in the wrong direction.

8. Just when you think you are done, shoot one more.

When you are doing this project, watch out for bright, sunny days as they will often make your subjects squint and look angry. It can also produce angular, unflattering shadows across the face. Keep this from happening by moving your group to a shady spot and using your fill-flash. Alternatively, you can tell them to look down at the ground, closing their eyes while you get ready. Once your subjects' eyes are rested and you're ready, tell them to look up just before you take the picture.

7. Photo Shoot: Asking a Friend to Model

Ingredients: A friend. Studio lights help, but any flash will do.

Subject: A model

Options: If you don't have a person, you can use an object and do a still-life instead.

Principles: Being the master of your flash; shooting off-center; locking focus and recomposing; altering your point of view

This differs from other kinds of people photography in that you control exactly how the model looks. While portraits are for the subjects, a model shoot is for you. You might do it to show off a new line of clothing, to advertise a product, or to make a collection of sellable images to offer to a stock photography company. Follow these steps when photographing models:

Figure 5.4 Our friend agreed to model for this photo shoot.

1. Secure a location.

2. Secure a model.

3. Gather a bunch of props, if you like.

4. Turn on your flash or set up your studio lights.

5. If you are shooting with studio lights, use a flash meter to determine the appropriate shutter speed and aperture.

6. Shoot the model in various places and poses. Especially if you are using kids as your models, be sure to get a few quick safety photos.

7. Shoot a bunch with your model off-center. Use your camera's focus-locking mechanism to hold the focus when you recompose, perhaps placing your model according to the Rule of Thirds.

8. Alter your point of view. For some shots, try looking down at your subject. For others, get low and look up at the model. Looking "up to" your subject will make them look dramatic and impressive. Looking "down on" your subject will likely create a flattering effect (by eliminating double chins, among other things).

8. Take a Hike! Taking Notes Along the Way

Ingredients: A good pair of comfortable walking shoes, notepad, and pen or pencil

Subject: Trees, adventure, nature, mountains, plants, wildflowers, wildlife

Principles: Getting out there; keeping your composition simple; appreciating the value of taking notes

When out on a hike, you can end up shooting anything from adventure sports to abstract art to pictures of beautiful, serene landscapes. The main point of this project is to just get out there, so grab your camera and head out for a walk.

On many occasions, I have been rewarded with wonderful pictures that I could not possibly have planned to shoot while sitting back at home. You never know what you will come across.

Figure 5.5 Hiking path in the woods

Figure 5.6 Detail of hiking boots

This project also gives you a chance to practice your note-taking skills. Like Ansel Adams said, a notebook is one of the most important accessories a student of photography can have.

> *The first rule of writing is to write.*
> —Sean Connery as William Forrester in *Finding Forrester*

1. Grab your camera and start walking.

2. Each time you see a shot, take a picture. The first rule of picture taking is to take pictures. Don't think; just shoot.

3. If you get stumped, simply take a picture that documents your walk. Tell a story about your adventure through pictures. Try to capture every interesting detail you can.

4. If you encounter any animals or people on your hike, be sure to include them in your photographic collection.

5. After each shot, quickly jot down the important points that you would like to remember. These details are among the most helpful:

 - *Shutter speed and aperture:* This will help you understand exposure.
 - *Your intentions:* You will be surprised how often you forget what you were trying to achieve—unless you write it down.
 - *Names of places, people, plants, animals, or any other subjects:* Especially when traveling, writing down these details on the spot is easier than looking them up when you are back at home.

From time to time, be sure to include, as a point of reference, what frame you are on. By taking notes in this

way, you won't forget the important details about the wonderful things you see and the lessons you learn.

This exercise will show you that subject selection is not as hard as you think. Inertia and apathy might tempt you to stay at home, twiddling your thumbs and thinking, "There just isn't anything interesting to shoot." As soon as you get out the door, you will learn that the opposite is really the truth.

Have a great walk!

9. An Exercise in Zooming

Ingredients: Zoom lens and a pair of good sneakers

Subject: Any. Using a friend as a model makes this a little more fun.

Principles: Zooming in; understanding how different lenses affect perspective; being aware of the distortion problem with wide-angle lenses

Figures 5.7–5.9 Zooming in, walking closer with each shot to keep my model's head at about the same size. Notice how the background changes.

Figure 5.7

Figure 5.8

Figure 5.9

1. Ask a friend to model for you. If a model is unavailable, choose a simple, relatively close object in your scene.

2. Choose a location and set up your shot. Align yourself so that something of interest appears in the background, off in the distance behind your model.

3. Shoot one picture of your subject from afar, with a normal or wide-angle lens.

4. Shoot a few shots as you zoom in closer.

5. Gradually begin walking up closer to your model or object, keeping the objects in the background in the picture. As you walk closer, zoom out so that your model remains roughly the same size as in your initial shot. Every so often, snap a picture.

6. As you go, carefully note your focal length and any other details that will jog your memory later.

After the photos have been developed, compare the different images. You should see how the initial, longer lens lengths captured a more flattering, natural look. The closer images with wider focal lengths will show your subject becoming more distorted. Even though your model remains roughly the same size in the photo, both you and your model will likely prefer the shots taken from farther away.

In the pictures that are taken from a greater distance, you will also notice that less background shows up behind your model, even though she remains the same size. This illustrates the effect that different lens lengths have on perspective.

10. Adding a Little Seasoning

Ingredients: A lot of time; a natural spot
Subject: Fields, mountains, trees, and so on

Options: The progression of development, such as a building or bridge being constructed

Principles: Understanding how the progression of time affects your photographic compositions; making a photo essay or series of photos that relate to one another; keeping your composition simple

1. Select a place close to home that will likely change with the seasons—the more natural and less urban, the better. This can be anything from a local park to a special tree in your neighborhood.

2. Walk around your subject, using different lens settings and angles until you find the composition you like the most. In this situation, you will probably want a serene, peaceful composition. Think "horizontal, with soft curving lines and no diagonals."

3. Set up your camera (preferably with a tripod) in the place you have deemed to produce the best composition. The tripod helps you set up the scene with a much-needed degree of control; you want to be able to find the exact same viewpoint months later. As this task can be more challenging than you might think, take measures to make it as easy as you can to find the same spot again.

4. Make several exposures of your scene, slightly altering exposure controls, if you can.

5. Come back at least once every season. Returning to the same place again and again, you will be able to produce an interesting series of photos that illustrates the effects of time and the seasons.

11. Getting Out of Town!

Ingredients: The means to travel

Subject: Castles, cathedrals, villages, the people of another place, and so on

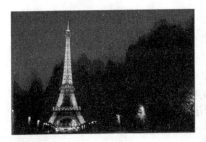

Figure 5.10 Typical travel photo of the Eiffel Tower

Figure 5.12 Even more unusual view

Figure 5.11 Different view of the Eiffel Tower

Principles: Finding inspiration in foreign places; traveling smart with camera and film; keeping your composition simple; shooting close-ups of details rather than trying to get everything into one shot; shooting more than just the usual snapshots that say nothing other than "I was here."

1. If you are planning to use a recently purchased camera, practice with it before you travel. It's best to get to know how to use it long before you are on location.

2. Look at pictures of the area you will be visiting. Study postcards, travel brochures, and anything else with good pictures. Review these photos, questioning what you like about each, to find inspiration and insight into selecting subjects. As you research, make a list of the

photo ideas that come to mind. This way, you will know what to look for when on the road.

3. Prepare film for departure. Remove all canisters of film from paper cartons and black plastic containers (you can leave film in clear containers) so security people are able to see each one.

4. Place these rolls into a clear, Ziplock baggie. This further facilitates the airport security experience.

5. If you are permitted to, carry on this bag of film rather than pack it in your checked luggage. Instead of sending your film through the x-ray machine, give it to the security agent and ask for a "handcheck."

Fun Fact!

National Geographic was seriously struggling until its sales went through the roof when, in the 1890s, photos were added to the textual descriptions of faraway places.

6. Start shooting even before you arrive. Many cool shots can be made even in the airplane, for example. Carry your camera everywhere you go.

7. Even if you do not speak the language, ask friendly looking people if you can take their pictures. People in many foreign cultures will know what you mean when you point to the camera and ask "Photo?" Politely sprinkle in a "Please" and "Thank you," and most won't be able to resist. Be bold, and you will be thrilled with both your photographic successes as well as the fun experiences you have.

8. Go for shooting at least two rolls in the morning and two rolls in the evening. You can take the mid-day off

and use that time to visit museums and the like. Still bring along your camera, but you can take it down a notch and shoot less if you like.

9. With each shot you take, ask yourself whether there is something more unique, more interesting that you can do. Try to get a new point of view on the subject. Think about what it is that you are after and let yourself imagine creative expressions of any scene.

> ### Helpful Hint
> When traveling, you can use a photographer's vest or create your own makeshift photography "belt" by wrapping a jacket with zipping pockets around your waist. Either way, use the pockets to carry film or accessories that you turn to most frequently. Just remember to keep the zippers tightly secured so gear does not fall out of your pockets. (Can you hear my lawyer talking again?)

12. Pet Portrait

Ingredients: A friend, a pocketful of pet treats, and, optionally, a tripod. Oh yeah, and a pet would help.

Subject: Pets

Options: Take your dog or cat out for a walk and do a photo essay.

Principles: Portraiture; posing; aperture and depth of field; acting with speed; keeping your composition simple by removing or eliminating unwanted, distracting elements; shooting quickly and taking a safety photo

Taking a picture of your pet is a fun, albeit challenging, project—especially when you sense that your pet doesn't want its picture taken. Also, try to make the best composition and capture the loved one with the best focus, exposure, and viewpoint. Remember to imagine how an unassociated

viewer will see the picture; otherwise, you may not be objective enough to produce a great shot. The following steps will help you maximize the likelihood of getting your best pet portraits.

1. Pick a pet. If you are a pet owner, the choice will be obvious. If not, decide which friend or family member has the cutest, most adorable pet.

2. Ask a friend to be the "Photographer's Assistant."

3. Put an ample supply of pet treats in your assistant's pocket. You might want one or two yourself (not to eat yourself, of course—unless you are really, really hungry—but to give to the pet when needed).

3. Set up your own makeshift portrait studio. This can be a picnic table at the park, a bench in the backyard, or anything that gets your animal up off the ground. This minimizes the animal's options and greatly facilitates your assistant's ability to keep the critter in one place.

4. Set up your camera as much as you can before actually shooting. A tripod will come in handy for this. Try to place the pet or reposition yourself so that the background is least distracting.

5. If you have control over aperture, select a large aperture to allow you to selectively focus on the pet. If you cannot directly control aperture but your camera offers a "portrait mode," choose it. Such a mode or aperture will help you slightly blur the background.

6. Now that you are all set up, place your pet in position and ask your friend to pet it and divert its attention while you finalize setting up the shot.

7. Once you are ready, do whatever works to direct your pet's attention back to the camera. This is a balancing act—getting the pet to look at you briefly without actually trying to come visit you. Working in tandem with your assistant to keep juggling the pet's attention between the camera and your assistant is helpful.

8. Take as many pictures as you can before it becomes impossible to hold the animal's attention any longer. Having a selection to choose from, you will be bound to get a pleasing picture of your little furry friend.

13. Sneaking a Peek: Candid Shooting

Ingredients: A quiet, compact camera works best.
Subject: People, informally photographed
Principles: Being bold; approaching people and asking whether you can take their photo; taking quick pictures with the least amount of intrusion; being quick and taking a safety photo

This project will show you how to get wonderful photos that look less formal and "staged" than your usual portraits. If you have kids, try it out on them and their friends. However, almost any public place will offer a number of photographic subjects. All it takes is the nerve to photograph them.

1. Get a relatively fast film. Black and white can yield some especially interesting results.

2. Decide on a subject. Two or more people interacting can provide fascinating character studies. Individuals may also give you some great material and will likely be a bit easier to shoot without attracting attention.

3. If you will be stuck in a stationary place for some time, such as in a restaurant, pretend to be fiddling around

with your camera, trying to figure out how it works or why it is not functioning properly. Resist the urge to hold it up to your eye. Instead, hold it on the table or at waist level and do your best to aim it at your target.

4. If you can move around, take only a few shots of any one subject, then continue moving on your way.

5. If you think you may have gotten a great shot, be sure to ask the subject for permission. Take the person's picture again in a more formal pose, get his or her name and address, and offer to send your subject a copy. Remember to do unto others as you would have them do unto you. Respect individual privacy and be especially considerate of cultural attitudes toward having one's picture taken.

14. A Trip to the Zoo or Aquarium

Ingredients: Possibly a telephoto lens
Subject: Animals
Principles: Moving in close; filling the frame with your subject (although sometimes people like to see the environment when shooting wildlife); eliminating distracting elements; focusing through glass and fences; shooting quickly; taking a safety photo

Aquariums and especially zoos are great places to go when you are in need of a subject. Everywhere you look, you will likely find an inspiring scene, subject, or object to photograph.

1. Get at least a few rolls of film. Fuji 400-speed is a great choice if you are shooting for color prints. Provia 400 and Kodak E100VS (if you have a tripod) are great options if you are shooting slides.

2. If your camera can accommodate one, get your hands on a strong telephoto lens.

3. Get thee to a zoo (or aquarium).

4. When shooting animals, be especially careful to exclude as much as you can of anything that does not contribute to the overall picture.

5. Always keep your camera ready. You never know when a "moment" will happen—between a cub and her mom, for example.

Figure 5.13 Koala sleeping in a tight spot

6. When shooting through glass, carefully observe your camera manual's direction on focusing. Some cameras trip up on focusing through glass. If you have such a camera, check to see whether you can turn off the auto-focus and focus manually. You may need to set the camera into an "infinity lock" mode, if you have one; this will lock your focus so that objects off in the distance will remain sharp. Also, some autofocusing systems will be confused by vertical lines, such as those in a fence. In such cases, you can turn the camera to a vertical orientation, lock the focus, and then turn back to the land-scape position while holding the focus locked.

7. Furthermore, when shooting through glass, remember to turn off the flash so you do not get unwanted glare reflecting back into the camera.

8. Remember to shoot in the vertical orientation when-ever it seems appropriate. For example, a close-up

portrait of a bear standing on its hind legs may work better in the vertical orientation.

Remember that animals are usually more active in the early morning and late evening, often feeding at these times. An active, alert animal is much more interesting in a photo than one that is napping, which many animals do throughout much of the day. Keeping this in mind, an early or late excursion to the zoo or aquarium will likely give you an enormous return on your invested time and effort.

15. It's Chipmunk Season

Ingredients: A telephoto lens comes in especially handy.
Subject: Chipmunks, squirrels, and other forms of "wild"-life
Options: If you really want a challenge, try instead to get good, close-up pictures of more elusive subjects, such as birds.
Principles: Being quick and taking a safety photo; moving in close

This project can be tackled with any camera, and it provides a fun and friendly way to enjoy the thrill of the hunt. Best of all, because the subjects are generally somewhat tame creatures, the level of difficulty is not as high as it is with truly wild wildlife.

1. Get a long lens or a camera with as much of a telephoto as you can get. If this is not an option, be prepared to face the challenge of quietly approaching subjects and getting as close as possible before being noticed.

2. Find a spot where squirrels or chipmunks congregate. Public parks are a good bet.

3. Camouflage yourself as much as you can. This project may require that you hide behind some foliage or an-

other "blind" for a long time before getting an opportunity to shoot.

4. If you do not have a tripod, stabilize your camera by resting your elbows on the ground or on another solid surface. You have to be especially careful about camera shake when your zoom or telephoto lens is fully extended.

5. When you finally do get an animal in your sights, shoot both horizontal and landscape images, moving in closer as you go.

6. Try to capture the most interesting moments, such as when the animal is at full alert or eating.

Figure 5.14 Picture of squirrel eating

7. You might also enjoy shooting several shots that show the animals in their environment or interacting with one another.

16. Copying Your Favorite Masterpiece

Ingredients: Another picture that inspires you
Subject: Any
Options: Visualizing a nonvisual art form such as literature or music
Principles: Originality in creativity; learning from the masters

This is one of my favorite projects. Unlike what you might expect, doing it can inspire you to produce some of your most original and beautiful photographs.

1. Find a painting or photo that you especially enjoy. This can be something you see in a magazine or on a postcard,

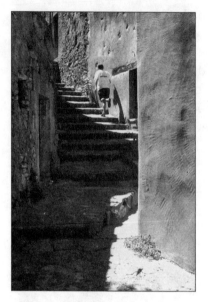

Figure 5.15 Self-portrait in Roussillon, France. This scene immediately reminded me of a photo by Henri Cartier-Bresson that I like. I spent the next fifteen minutes having fun trying to copy Cartier-Bresson's photo. (You can see the original in the first chapter of *Basic Photography* by Michael Langford.)

or it can be a work of art done by one of the past masters.

2. Analyze the image and try to figure out what you like about it. Break it apart into its most basic elements—color, form, texture, composition, concept, and so on. Do your best to determine what first attracted you to the image and why you continue to appreciate it.

3. Once you have a pretty good idea of what the image is all about, set about trying to copy it. That's what I said: copy it. Don't worry about plagiarizing. The fact of the matter is that it is incredibly difficult to come anywhere near making a perfect copy. If your intentions are open, honest, and artistic, you will most likely end up with something very different and new. In the process, though, you will learn a lot about technique. You will come to appreciate the masterpiece even more and end up with your own masterful knowledge of how such an image is made.

Option: Use a work of art from another, nonvisual form of expression. For example, if you particularly enjoy a certain novel or musical composition, see if you can imagine a way of representing the work with a photographic image. If you are looking for something to do, this can give you a ton of photographic ideas and projects to pursue.

17. Making Your Own Abstract Art

Ingredients: Possibly color-saturated film
Subject: Abstract art
Options: Using black and white instead of color film
Principles: Seeing photographic subjects in new ways;
noticing and orchestrating graphic elements
to create unusual compositions

In this project, you will try your own hand at making an especially abstract photo. Try to photograph something so that it becomes harder to define and understand, perhaps even becoming barely recognizable.

> *Abstract art is the product of the untalented, sold by the unprincipled to the utterly bewildered.*
>
> —Al Capp

1. Select a subject. Some of the best subjects for abstract art are extreme close-ups, color studies, and items with readily apparent graphic elements. Scenes in the natural world will often include soft, curving lines and shapes, while those in a more urban area can provide more angular elements.

2. When you find a subject you can work with, begin experimenting with views. Try positioning yourself or your scene so that it becomes less identifiable. Take several pictures to make these abstract, artistic statements.

3. If you get stumped, try moving in closer.

Photography is an abstract art, even though it seems to be the most realistic of arts. By redefining our three-dimensional world into two dimensions, any photo essentially "abstracts" reality. Some photographers find it helpful when **shooting abstracts** to use a saturated, color-intensive film

such as Fuji Velvia or Kodak Portra 160 VC. Alternatively, black and white film offers another way to further abstract an image from reality—by removing any reference to color at all.

18. To Bee or Not to Bee: Macro Work

Ingredients: A macro mode or lens
Subject: Small insects
Options: Any other small items, such as stamps, coins, jewelry, or flowers
Principles: Working with the close focusing distance; compensating for the parallax problem; shooting quickly and taking a safety photo

1. Go out on a bug hunt. If you don't like butterflies or bees, choose any small object you like. Any subject will do.

2. Just before you shoot, be certain that you are not getting closer to your subject than your focusing mechanism will allow. Some cameras such as 35mm SLRs will show a blurry view through the viewfinder when this problem occurs. Others will try to warn you by way of a focus-ready light. Still others will do nothing. Short of reading the manual, you may have no way to know with this last group of cameras if your close-up subject is sharp.

3. Point and shoot users: As you get close to your subject, be especially certain that you are aiming correctly. If you see lines near the top and left of your viewfinder, you will probably need to realign your picture to those marks. Even if you see the subject correctly through your viewfinder, your lens is likely to capture a slightly different scene. You will read more on this problem, called *parallax*, in the next chapter, "Troubleshooting."

4. Once you are relatively confident that you are within the focus range and are getting the correct view of the

scene, take a picture. Shoot several, especially if the breeze is strong. Wind can cause your bee, butterfly, or the plants around your subject to record as nothing but blurs. Taking a number of photos will maximize the likelihood of your getting a winner.

19. A Photo Shoot in Black and White

Ingredients:	An extra camera is helpful but not required.
Subject:	Any
Options:	Sepia effect (with C-41 film or digital); hand-coloring the images; using Infrared film
Principles:	Seeing graphic elements without the distractions of color

1. Pick a black and white film. Compared to color film, black and white is offered in a very small selection of choices: Tmax, Tri-x, Ilford, Fuji Neopan, C-41, and a handful of others. This makes choosing one all the easier. If you are unsure of which to select, ask the salesperson at a reputable camera store about the characteristics of each.

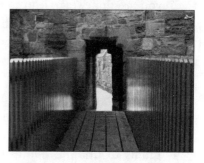

Figure 5.16 Black and white study of graphic lines found on a drawbridge in Wales. Photo by Denise Miotke

2. Whether the sky is clear or cloudy, head out shooting. As was discussed in chapter 4, "Beyond the Basics," black and white is actually great to use when shooting boring skies on overcast, dull days.

3. As you go, be sure to shoot at least a few people photos. Portraits without color can be extremely attractive and pleasing.

4. Look for an especially busy scene, with lots of clashing colors. If you have a friend with you, ask him or her to pose in front of the scene while you take a few pictures. If you have two cameras with you at the time of shooting, load one with color film and the other with black and white so you can compare the results later. Even if you cannot compare two rolls of film, simply imagining how the photo would have looked in color can give you a good idea of how the two differ.

5. When the shoot is over, take your film into a lab. Which lab you choose and what process they use depends on what kind of film you shoot. Order an enlargement to be made from one of your favorite images. If you see dust or hair, ask them to spot the image or reprint it.

Option 1: Use a film that is marked as "C-41" and, when you are done, take it in to a normal photofinishing lab. Ask them to try to print it with a slight sepia tone. This process can also be done digitally; various software programs feature tools that allow the user to tint an image so it takes on that old-time, sepia look.

Option 2: Get some color pencils and hand-color the photo just the way you would like it. If the picture is in a digital format, you can also use computer software programs to tint the photo. Either way, this takes an artistic touch but can be a lot of fun.

Option 3: If you are interested in an otherworldly, grainy effect, try doing this shoot with infrared film. Some cameras do not cooperate with this kind of film, so check your manual or ask the salesperson at a pro camera store when you go buy the film.

20. E-Mailing a Photo to a Friend

Ingredients: Digital camera or a scanner; image-editing software

Subject: Any

Options: Uploading a photo to a Web site

Principles: Dealing with digital concepts; editing and presenting your best work

1. Select an image that you particularly love.

2. If the picture is a print, negative, or slide, you can either scan it yourself or bring it into a photofinishing lab to be scanned. Call around to see if a lab in your area offers scanning services. If you have a choice, a negative or slide will scan better than a print.

3. Once you have the picture in a digital format—on a CD-ROM, memory card, floppy disk, or other storage media—you can copy it over to your own computer.

4. Open up the photo in an image-editing software program. If you do not have a commercial program such as Adobe PhotoDeluxe, Adobe Photoshop Elements, PhotoSuite, PhotoImpact, PhotoDraw, or another of the many programs available, you may be able to download a free or shareware image-editing program from the Web. Search and see what you can find.

5. This step varies greatly depending on what kind of software you use, but the principles are the same. You want to find a way to resize your image, ideally down to something like 400 pixels on the shorter end. Set the resolution down to 72 ppi. If you cannot find these functions in your software, consult the manual and the program's "Help" documentation. The general idea is that when you transfer the image file, you want it to be as small as possible while still being viewable. Big files take a long time to load.

6. Once you have the image correctly sized and looking just the way you want it to look, save it as a JPEG file

with a relatively high-quality setting. With some pro-
grams, you may find it very difficult to change this
quality setting. If you cannot locate this function, save
it with the default settings and then open up your
saved version to make sure it looks okay.

7. Open up your e-mail program and start a new
 message.

8. Before you write the body of the e-mail message, look
 for a function that allows you to "attach" a file. Use
 this function to locate and attach the JPEG version of
 the file that you just saved.

9. Write your e-mail and send it. If you want to be espe-
 cially certain that everything is operating correctly,
 send this e-mail to yourself first. If everything looks
 good, send it again, this time to your friend.

 Alternatively, you can upload the photo into an online
gallery or album. Simply replace steps 7, 8, and 9 with the
Web site's instructions on uploading images.

6

Troubleshooting: Solutions to Common Photo Problems

We've all been there. Getting bad images back from the lab leaves us with a terrible feeling. Gathered around the living room with your friends, you flip through the images and, one after another, they seem to prove only one point: You, your camera, and your photofinishing lab do not work well together when it comes to making good pictures.

The truth is that you have what it takes to be a great photographer. If you have already read chapters 3 and 4 on the basics and secrets of photography, you know what you need to know to take stunning pictures. Furthermore, your camera, while playing a part, does not have the final say in the quality of your pictures. Nor does the photo lab determine your success as a photographer. At this point, you need to know how to identify and overcome a few common hurdles that everyone experiences while traveling the photographic path.

WHEN BAD PICTURES HAPPEN TO GOOD PEOPLE

All kinds of problems can creep in when you're taking pictures. Your equipment could fail to deliver on its promises. You might run out of film. Your camera could stop functioning for no apparent reason. At other times, the action happens too fast for your camera to keep up with it. Problems with a particular scene you are trying to photograph might rear their ugly heads just when you least expect them. Sometimes you simply miss the shot; the moment comes and goes before you can get the camera out of the car. And even if both you and your camera manage to do everything right, problems can still happen when the film is developed improperly by the photofinishing lab.

You can end this nightmare of receiving bad pictures from the lab once and for all by taking a few suggested precautions. Use the following guidelines to greatly reduce your likelihood of experiencing common problems.

So you can quickly find the answer you need, typical problems are arranged by symptom. Before you begin to troubleshoot the problems you see in individual photos, though, you need to answer a few preliminary questions.

FIRST THINGS FIRST: A LITTLE DETECTIVE WORK

When you are not getting the results you hoped for, do a bit of detective work. First, answer the following two questions:

- Did all the pictures on the roll or just a few of them turn out bad?
- Are you shooting with regular print film (negatives), slides, or digitally?

Addressing these two issues as your first step in troubleshooting will give you some important clues toward determining the cause and finding solutions to the problem.

When the Whole Roll Is Toast

Occasionally, when you pick up your pictures, you will be handed nothing but a set of negatives. The whole roll of film will either look like transparent, brownish plastic or will be pure black. When this happens, use the following diagnostic guidelines—which apply to regular print negatives rather than slides—to help you understand what went wrong.

When the roll of film is pure black, this indicates that the film was completely exposed to light. Perhaps the camera back was inadvertently opened at some point, or maybe the film was pulled out of its canister. Promptly rewinding and removing the film out of the camera immediately after finishing it will help minimize the likelihood of its getting ruined by someone prematurely opening the camera. Also, cameras by some makers (such as Fuji) wind the film back into the cartridge after each shot, reducing the risk of light damage. And to keep exposed film from being pulled out of its canister, wind the last few inches of it into the canister after you are finished shooting the roll.

If your whole roll of film is clear, this means that you accidentally handed in an unshot roll for processing. As opposed to the tragedy of losing all your precious pictures, only a roll of film is lost in this case. If, on the other hand, only a few shots on the roll are clear, perhaps you left the cap on the lens or maybe your flash failed to fire.

A roll of film that is mostly clear with just the first frame completely black usually indicates that the film did not advance properly. Every shot was exposed onto the same frame of film. Make sure you are loading the film properly and that the film winder is working. Consult your local camera store to see whether you need to send your camera in for repair.

Shooting Slides, Negatives, or Digital Images?

When shooting with negatives, a bad print does not necessarily mean that you or your camera did something wrong.

Figure 6.1 Film negatives with two extremely underexposed images on the left and two properly exposed images on the right

Perhaps the photofinishing lab printed your picture incorrectly during the extra step in the developing process. Even if a picture is correctly exposed, for example, the lab can easily print it too dark, too light, too yellow, too blue—you name it. Judging how a picture should be printed is a subjective art that involves a lot of guesswork.

When you hold a terrible print in front of you, ask yourself whether it can be fixed with a simple reprint. Although many problems are impossible for any lab to correct, some are easy to fix. Don't feel embarrassed to ask whether a particular image might be salvaged or reprinted correctly. Most professional photo labs get such requests every day.

The flip side of the fact that a good photo lab can often correct prints is that troubleshooting gets much more complicated. If you have a bad print, you may have a hard time figuring out whether the negative is bad (if you or the camera shot it poorly) or if the photo lab is at fault. For each of the following problems, I will address the issue and make sure you explore both possible causes when applicable.

If you are shooting slides or using a digital camera, you can rule out printing problems. When you look at slides, you are looking at the actual film that went through your camera. It has simply been developed, sliced up into rectangles, and mounted in little cardboard or plastic frames. Because you are looking at a direct representation of what you shot, you have fewer factors to consider when judging exposure and the like. This is one reason professionals and seri-

ous students of photography like shooting slides so much: analyzing problems as they occur is much easier when shooting slides. Most people shoot with negatives, however, so they can easily get color prints to put in their albums. The majority of the examples in this chapter apply to all three categories.

When the problem relates specifically to one kind of photography or the other, I will let you know.

Whether you shoot slides, prints, or digital images, the most prevalent—and obvious—problem is the dreaded blurry picture. Let's look first at the various types of blur and discuss what we can do to overcome them.

FUZZY WUZZY WAS A BEAR: PROBLEMS WITH FOCUS

Believe it or not, blur comes in many shapes and sizes. At times, everything in the picture is a blur. Then at other times, only one part of the scene will be out of focus. Unfortunately, the blur usually occurs in the most important part of the picture. Maybe the subject moved or was too close to the camera. Or perhaps the camera focused on another element in the scene. At still other times, your whole roll will look a little soft and fuzzy due to a problem with film grain.

It's All a Blur: When the Entire Picture Is Out of Focus

An entirely blurry picture usually means one thing: camera shake.

Camera shake occurs when slow film speed, lack of light, and the lack of a tripod conspire to cause your camera to take its own sweet time exposing the picture on film. It can be severe, or it can be slight. You might see that your picture is extremely out of focus, or you might notice it only in the eyes of your subject. When the photo is slightly blurry, or *soft*, you can bet the farm that the problem is camera shake.

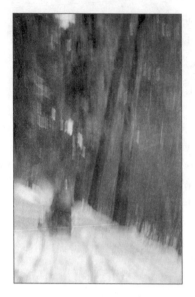

Figure 6.2 Snowmobile trip, blurry due to camera shake

To minimize the risk of camera shake, try using a faster speed film when you are forced to shoot in low light conditions. Better yet, use a tripod to keep the camera from moving as you're taking the picture.

If the problem persists, the camera might be malfunctioning and failing to focus. Have someone at a repair facility check your camera.

The Wrong Part of the Picture Is in Focus

When only a part of your photo is out of focus, it is likely due to you or your camera improperly focusing on the wrong point in the picture. More than just overall blurriness, this relates to knowing what in your scene deserves the most attention, what the viewer's eye will be led to look at.

A common contributor to this problem is that most cameras focus on whatever is in the absolute center of the viewfinder. For example, if two objects in your scene are obviously intended to be the subjects of your picture, your camera might not know this. Without instructions from you, the camera will focus on the background in the center of the scene, throwing everything else out of focus.

Figure 6.3 These two teacups, although they were intended to be the subject, are blurry. The camera is focusing instead on the candle in the center of the picture.

The solution to this problem is to learn how to lock

the focus on your camera. Once you know how to do this, you can center your subject, focus on it, lock the focus, and then recompose so that the subjects are back where you want them to be.

Figure 6.4 Heidi jumping off the picnic table

The Subject Has Moved

Sometimes the subject is blurry because it moves just when you are taking the picture. When one moving part of the picture is blurry in this way, this means that your shutter speed was too slow to stop and capture the action. Solutions include using a faster speed film such as ISO 400 or 800, shooting in brighter conditions, or finding some way to keep your subject still.

Too Close for Comfort

Most cameras will not focus properly when you get too close to your subject. To ensure that this does not happen, learn your camera's close focusing distance. This distance can range from just a few centimeters to a couple of yards or more. Consult your manual to find out how close you can get. Then take measures to

Helpful Hint
Getting a great photo of your pet can be a tough assignment. Here's a quick trick: Place small dogs and cats on a table to get them to sit still temporarily. If they still prove too restless, have a friend help by distracting them and keeping their attention while you set up and shoot.

Figure 6.5 The cockatiel should be sharp, but the camera is too close to allow that to happen.

Focal Conflict: What Happens When the Subject and the Sharp Part Don't Match Up

Occasionally the subject of the photo, even if it is not in focus, can attract the viewer's eye more than anything else in the picture. For example, the eyes generally attract a lot of attention in any photo. If the eyes of our subject are not perfectly sharp, the viewer will be unsatisfied with the photo.

keep this amount of space between you and your subject. If your camera features a focus-ready lamp in the viewfinder to tell you when the camera is focusing properly, pay attention to it whenever you get close to your subject.

With a Grain of Salt: Side Effects of Using Fast Film

If all the photos on your film look a little unclear, the problem might have nothing to do with your camera's focusing system. This problem, which is called grain, is caused by using a very fast speed film such as ISO 1600.

In addition to the speckled, grainy texture, you might also notice that the colors are dull and drab. The dark parts in the photo may look better than the light ones, but you will still see tiny specks all over the picture.

Some people like this grainy effect, which is certainly better than getting shots that are extremely blurry due to the camera-shake problem. If you are not going for the grainy look, how-

Figure 6.6 Grainy picture of Hawaiian lighthouse

ever, use a slower speed film such as ISO 100 or 200. If shutter speeds get so slow that you need to keep the camera steady, use a tripod to avoid camera shake.

USING AND ABUSING THE FLASH

The little flash on your camera can be a godsend, but it can also be the cause of many photo problems. When your flash does not do its job properly and fails to illuminate a scene with enough light, problems are likely to occur. The lack of flash can cause everything from unintentional silhouettes to shadowy dark scenes in which it is hard to make anything out. In addition to lack of illumination, your flash can cause problematic pictures in these situations:

- Too much flash flooding the subject
- The flash pointing in the wrong direction
- The flash too close to the camera lens

Malfunctioning Flash

A picture that is mostly black can mean that the flash simply refused to go off when it was needed.

Figure 6.7 The flash malfunctioned and did not fire in this picture, resulting in an underexposed photo. To see what was lurking in the darkness, look at figure 6.9.

Closely monitor the performance of your flash. If you are not sure, ask those around you if they noticed whether the flash fired or not. When they are not sure or say no, shoot again. Your flash will often eat up the most battery power, so carry an extra set of batteries—just in case a lack of electrical power is to blame.

Also note that a grossly underexposed negative, caused by a camera malfunctioning so that it did not flash, might be printed in a photo lab as a very light, obscured, and

grainy-looking print. See the section on underexposure for more information.

Too Dark; Use Flash

In addition to occasional poor prints caused by a malfunctioning flash, your camera might have simply thought no extra light was necessary. Even when your flash is functioning properly, it might know less than you do about when it is required.

The flash will most often get tricked into staying dormant when the photo includes a large, bright area. For example, you might be shooting the interior of a room with a window in the background. This window would likely throw off your camera meter, causing it to think that no flash is required. The resulting image will expose perfectly for the view outside of the window, but everything in the room will be rendered much too dark.

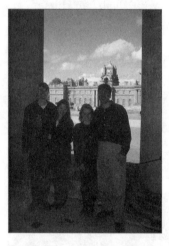

Figure 6.8 Portrait at Blenheim, England, without flash. The camera thought it had enough light because of the bright background.

If you can, force on your flash so that it fires regardless of what the camera would like to do. Also, watch out for extremely bright or extremely dark areas, such as the large doorway in figure 6.8. When you see a bright area like this in your scene, either change your view or force on your flash so that it fills in the shadows and evens out the extremes in contrast. If your camera sports an exposure-lock feature (a function for locking exposure that works much like focus lock), use it to get the correct exposure. For more on exposure, see chapter 3.

Blinded by the Light

When our overzealous flash attempts to save the day by blasting away, we may see our subjects turn pale, as though they

have seen a ghost. And that says nothing of the fact that we temporarily blinded our subject with the bright flash of light.

To avoid this, you can lessen the harshness and brightness of the flash by stepping back a bit to create more distance between the subject and your flash. Alternatively, if your camera allows it, you may be able to use a diffuser or bounce the flash off the ceiling to soften the light before it reaches your subject.

Figure 6.9 This is the same scene as in figure 6.7. The flash went off in this photo but produced too much light.

That Little Red Devil: Red-Eye

Many times, people or pets stare back at us from photographs with glowing eyes, suffering from an unholy condition that the high priests of photography call "red-eye." Although they may have been perfectly fine before we took the picture, our loved ones show up in our photos looking like zombies of the night.

This problem most often sets in when the lights are low because the effect is accentuated when the pupils have dilated. The red-eye, in actuality, is the light from the flash reflecting off the retina and back into the camera. All this happens within the instant the picture is taken.

If you can, flood the area with as much light as possible before taking the picture. This way, the eyes will not be as dilated and the problem will be lessened.

If this is not an option, the best solution is to move your flash, if possible, farther away from the lens itself. This way, the light does not bounce straight back into the lens. Instead, the bulk of it angles off to the side and never finds its way to the film.

However, getting a camera with a flash that can be placed farther from the lens is an expensive prospect. Camera makers

Getting the Red Out

Some pen manufacturers and software programs claim to be able to take the red out. Any photo retouching is essentially like painting; it takes an artist's touch. This artistic work is unbelievably difficult when working around the eyes, where every minor mistake is especially noticeable. If you feel like taking on this task, start out by practicing on a copy rather than on the original photograph.

have tried offering a number of less expensive options for reducing the risk of red-eye, including the curious tactic of flashing a light in the eyes just before taking a picture. Although these red-eye reduction systems may help, they are usually annoying and only occasionally effective. You are not the only one who feels these flash features are not doing their job.

That may be why an entire cottage industry has sprung up to fix red-eye after it happens. If you have a print that suffers from red-eye, try a red-eye removing pen. If you know your way around digital imaging software, you may be able to use it to correct the red-eye problem.

Figure 6.10 Having the flash too bright and our model too close to the background caused a sharp shadow to appear behind her.

Flash Shadows

Many pictures taken with an on-camera flash can suffer from effects other than red-eye or overblasting. The flash can often cast a heavy shadow behind your subject.

To minimize this problem, move your subject farther away from the background. If this is not possible or does not help enough, soften the flash with a

diffuser or by bouncing it off of the ceiling or wall. (Note: Bouncing light requires a flash unit that allows you to change the direction of its light.)

Flash Reflections

When you use the flash, make sure that you are not facing any reflective surfaces, such as a window. Taking the picture in such a position will produce distracting glare and result in a photo similar to the example shown in figure 6.11. Windows, mirrors, and glass picture frames bounce the light back into the camera and create a surprising and distracting burst of light.

Figure 6.11 The face of this clock is partially obscured by the glare.

To keep this glare from happening, simply reposition yourself so that you are at an angle rather than facing the reflective surface head-on.

PLACES, EVERYBODY: COMPOSITIONAL PROBLEMS

The following problems all relate to how elements in the picture are arranged. Some photos suffer from surprise elements that get into the picture. Others suffer because they do not include what you intended them to include. A few problems relate to how your subject is proportioned or balanced with other objects.

Subject Is Too Small or Far Away

Especially when using a camera with a wide-angle lens, objects may appear smaller in the photo than in real life. In fact, the eye prefers looking at the big stuff in a picture, which is what captures our attention. When your subject—whether a bird, your spouse, or even the moon—appears tiny and inconsequential, the photo will be less enjoyable and meaningful to the viewer.

If your photos display this problem, shoot with a stronger telephoto lens or from a closer vantage point. Determine what it is about the scene that interests you in the first place and shoot it. Then, if you can, take a few steps toward your subject and take another picture. Keep moving in until you think you have created an effective photo. Then move in some more.

Moving in like this will help you avoid including too much empty, negative space or too much clutter around your subject. Rather than trying to get everything in each photo, select one subject and move in, filling the frame with your subject as much as you can with each shot.

"I Could Swear That Wasn't There When I Took the Picture!"

Every once in a while, you will be surprised to see things in your printed photo that you didn't see when you shot the picture. Perhaps a big, blurry, and mysteriously flesh-colored blob shows up in your picture. Or maybe what looks like horns appear to be growing out of your model's head. At other times, a bit of distracting debris may be visible in the background.

You can usually avoid this by remembering to closely scan the entire scene before you press down the shutter button. Sometimes, though, your surprise element is a result of poor printing at the photofinishing lab. Therefore, we will look at a few forms of this problem and their related causes.

Surprises Near the Edge of the Picture

Every once in a while, you might notice a blurry blob reaching into your photo. If the blob is flesh-colored, most likely your thumb or finger was hanging in front of the lens when you took the picture. This is most often caused by improper holding of the camera and can be remedied by keeping your fingers back and away from the lens.

Point and shoot camera owners can hold their camera by each end, with the right index finger over the shutter but-

ton and any fingers that might get in the way pulled tightly into the palms.

Users of the 35mm SLR will usually want to hold the camera with their right index finger over the shutter button and their left palm cupping the camera and lens from below.

Black Objects Making a Cameo Appearance

If the foreign, intruding element is black and snake-like, your camera strap or a cord of some type might be dangling in the picture.

The only solution to this is to pay close attention to what you are shooting. Point and shoot users, who actually look through the viewfinder rather than directly through the lens, should carefully check the area in front of their lens from time to time.

Figure 6.12 Stretching across the lens, a camera cord got in the way of this still-life photo.

Up-Close Fences, Wires, and Branches

You might shoot through a fence or screen without noticing these distracting elements at the time of shooting. This problem is especially likely when you're taking pictures at a zoo. Move your camera until you can view the scene from between the lines in the fence. If it enables you to clear the fence, try taking a snap or two hold-

ing the camera above your head, doing your best to blindly aim your camera at your subject. If you do this, take many pictures to increase the likelihood of getting one shot that successfully captures your target.

However you manage it, make sure distracting

Figure 6.13 Gazelle with distracting fence wire

elements are not in view through the lens before you take your picture. Otherwise, they will appear much more distracting in your final print.

Antlers
Another problem can occur when you do not pay especially close attention to what might be lurking *behind* your model. Ordinary items such as tree branches, bushes, and telephone poles can be mysteriously transformed into unattractive headgear. If you are not careful, you can end up with anything from antlers to antennae, or some other horn-like protuberance "growing" out from your model's head.

The solution is to scan the scene, looking carefully through the viewfinder, before you press the shutter button. If anything looks even remotely like a potential comical distraction, reposition yourself or your subject until it is out of your picture.

What's Missing from This Picture?
Only one thing is worse than being surprised by extra, unwanted subjects in your photo, and that is not getting those you do want. Pictures that include intruders such as dust or a hair can often be retouched to eliminate the extra items. It is much harder, if not impossible, to get part of your subject back in the picture. The following examples illustrate the problem of missing parts of your subject.

Off with Their Heads
Almost everyone has had the unpleasant experience of having his or her head chopped off in a photo. A less severe but also undesirable effect occurs when the subject's feet are removed at the ankle or his arms are cut off at the elbow.

This is usually the result of photographers being less than 100 percent aware of the scenes they are photographing. Perhaps they were no longer looking carefully through the viewfinder at the moment they snapped the picture.

Children often cut off heads because they don't realize that when they push down the button on the top of the camera, they also slightly tilt the camera downward. People wearing glasses may have difficulty seeing all four edges of the camera view through the viewfinder.

To avoid this problem, keep your eye on the subject and continue to carefully scan the entire area that you see through the viewfinder as you take the picture. If you wear glasses, you may be able to get a special "dioptic adjuster" for your viewfinder. Alternatively, if possible, consider wearing contact lenses when shooting.

Chopped-Off Edges

Figure 6.14 Off with the head!

Occasionally, chopped off heads and feet can also occur because the photofinishing lab trims off too much of the photo's edge. Enlarging a 35mm negative to a 5" × 7" or 8" × 10" print, for example, will force lab personnel to trim off the ends in order to keep the proportions the same. Because a 35mm rectangle is not quite the same shape as a 5" × 7" rectangle, trying to print the picture in the latter shape would require squeezing the image along the long dimension. To avoid a disproportionate image, most labs simply trim off the ends.

The best solution to this problem is to leave a little extra room on the top and bottom of your image whenever you take a picture. If you shoot the image without leaving extra room at the top and bottom, ask the photo lab to leave the edges on the print when

Figure 6.15 Because this shot of the Notre Dame cathedral in Paris is too tight, an 8" × 10" enlargement would result in its top and bottom being cut off at the dotted lines.

you order an enlargement. Alternatively, ask them to make an enlargement that is, for example, 6.7" × 10", with the short end just a bit shorter than the usual 8". It should not cost any more than a usual 8" × 10" enlargement. Your picture will not fit perfectly into a standard 8" × 10" frame, but at least you will have the image in its entirety.

If It Was a Snake, It Would Have Bit Ya

Many photographers miss the target and get less than they expected when shooting macro or close-up photography. If

Figure 6.16 Lavender in the hand missed due to parallax

you have been taking close-up photos and are stunned by how far off-target the prints are, you can probably chalk up the problem to parallax. Parallax happens to point and shoot camera users who get too close to the subject. As the camera gets closer to the subject, the lens no longer sees the same scene the photographer sees through the viewfinder.

To get more accurate close-ups, make sure you follow your camera's instructions about framing close-up photos. The solution will most likely involve adjusting your aim a bit to the left and using a set of small marks in the viewfinder to realign your subject just before shooting.

SLR users don't have this problem because what they see through the viewfinder is what the camera sees through the lens. They end up with the same image that they originally viewed.

Other Compositional Problems

Figure 6.17 Lavender in the hand corrected

In addition to having things creep into or inexplicably disappear from your photo, you might experience other prob-

lems. Your subjects could be unbalanced or suffer from out-of-whack proportions. You might see evidence of dust or hair on your pictures or, if you are even less fortunate, signs that your photos were scratched.

Leaning Tower of Pisa

The use of an extreme wide-angle lens can make items in your scene look distorted and warped. Buildings might look like the leaning Tower of Pisa.

If possible, use a longer lens length and physically back up to lessen this distortion effect. Either zoom in a bit closer to the scene or use a more normal or telephoto lens.

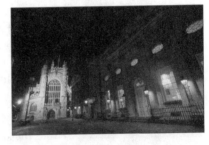

Figure 6.18 This photo of Bath Abbey at night is warped and distorted due to the use of an extreme wide-angle lens.

Tilt-a-World: Keeping the Horizon Level

You might be surprised when you notice that the horizon is a bit slanted in your developed photo. If you feel as though you are about to roll off the edge of the world, you probably simply tilted the camera a bit when you shot the picture. This mistake is easily made by those who wear eyeglasses or are leaning over to look through the viewfinder.

If the tilt is not extreme, you can salvage your print by cropping the photo. Simply trim off the edges at parallel lines to your horizon. Also, many minilabs will be happy to help you crop the image to correct the tilt effect.

Little White Dots: Dust

When dust gets in the way at the photofinishing lab, your prints will show tiny white dots. If you see this, take your prints back to the lab and ask to have them spotted. When viewing slides, dust will show up as little *black* dots; simply use an air blower to dislodge dust from slides.

"Waiter, There's a Hair in My Photo"

Curly, white lines in a photo are hairs that have gotten in the way at the photofinishing lab. If the images are important to you, take your prints back to the lab and ask to have them reprinted.

Slides will show hairs as little black lines. Use a can or blower of air to dislodge the hair. Do not directly touch or rub the slide with anything, as doing this can scratch it.

Little Straight Lines: Scratches

If your photo shows straight lines stretching across all or part of the picture, your negatives are scratched.

Figure 6.19 Portrait marred by a hair as well as a bit of dust

This problem can be caused by debris in your camera or in the film canister or by poor handling at the photofinishing lab. First, gently clean your camera to ensure that dust and tiny particles of dirt are not damaging your film as it goes through the camera. Also, make sure that you keep film in its plastic container until you're ready to load it in your camera; this will minimize the likelihood that debris will get stuck in the felt that lines the canister's opening.

If this problem only happens when you take the film to a particular lab, or if it persists after you take all other cleaning measures, most likely their processing and printing equipment is dirty. Talk to the manager or owner of the lab. If the lab does not resolve the problem, take your business elsewhere.

LET THERE BE (THE RIGHT AMOUNT OF) LIGHT: EXPOSURE PROBLEMS

Troubleshooting the problems that result from improper exposure or improper lighting can be the trickiest. The prog-

nosis depends on whether you were shooting slides or print film. If using print film, you may be able to salvage an image by getting the photo reprinted. You might, however, have a difficult time figuring out what is wrong with the photo and what actually caused the problem.

Underexposure

At times we can barely make out our subjects, as they are obscured by bad lighting and therefore are imperfectly exposed. Perhaps they were photographed in a dark room with a bright window behind them, captured as an unsatisfying silhouette against the overly bright light. Other times, the face is hidden in the shadows, forever lost from our sight.

Underexposure is among the most common troublemakers for photographers. Photographers often describe severely underexposed photos as "muddy." The dark parts of the picture look fuzzy, weak, and brown rather than pure black. This muddiness typically means the camera incorrectly evaluated the scene, usually because its meter was tricked by a bright light source in the background of the picture, such as a window.

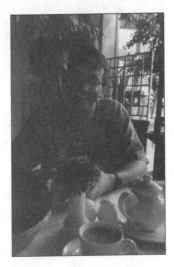

Figure 6.20 Underexposed in a restaurant at Butchart Gardens outside Victoria, British Columbia

Underexposed, "muddy" pictures resulting from incorrect meter readings look much the same as those produced when the flash malfunctions, refusing to fire at all. As such, this problem can usually be corrected with the use of fill flash. Turn on your flash to force it to fire even when it thinks conditions are too bright. Alternatively, you can work to eliminate tricky bright light sources from the composition by moving around. Or, if your camera has one, try your exposure lock function.

If the problem continues and is consistent, replace your battery. If it persists, have your camera checked to see whether the meter is faulty.

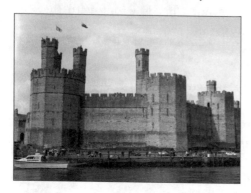

Figure 6.21 Caernarfon Castle in Wales. Light leaks can be seen along the left edge.

Leaking Light

If only certain areas are extremely bright and perhaps even burnt-looking, perhaps the film was not totally protected from sunlight. Your camera may no longer have a perfect, light-tight seal. Make sure when you are shooting that the back of your camera is not opened even a crack. If you're keeping your camera together with duct tape, it's time to get a new one.

If your camera seems in good shape yet you consistently see this problem in your pictures, have your camera checked for light leaks at a repair facility. If the camera was not expensive, the cost of repair may be more than the cost of buying a new camera.

Heavenly Glow All Around

At times, almost invisible subjects seem to blend into a white, misty sea of nothingness. If the entire picture is too bright, the most likely cause is overexposure. Check to make sure you have the ISO rating set properly; for example, if you're using 100-speed film, make sure your camera knows that it should be exposing for 100-speed film. As cameras have various ways of setting film speed, check your manual to see whether your camera allows you to adjust film speed and, if so, which dials, buttons, or modes you need to change. Shooting 400-speed film with a camera that thinks it is shooting 100-speed film will result in overexposure.

Those with more sophisticated cameras should also make sure the exposure compensation feature is not being improperly employed. Exposure compensation is a feature—common in many 35mm SLRs—that allows you to slightly adjust the amount of light that gets to the film.

Figure 6.22 High school reunion portrait, greatly overexposed digital image

If overexposure persists, replace the battery your camera uses for its light meter or take it to a repair shop for an estimate.

A Second Sun and Other Beads of Light

You may see bright streaks and spots appearing in your photo. These are usually sunspots and flare, which are beams of light that sneak into your lens while you aren't looking.

This happens most frequently when you are facing the sun. However, you need not always keep the sun behind you. If you feel inspired to shoot with your scene backlit by the sun, go for it. Just use a lens hood or your hand to shield your lens from direct sun and prevent the light beams from causing flare.

Spots like this can also be caused by water on the lens or on the film. If you have the sun at your back, are shading your lens with a hood, or if the weather is misty and wet, make sure the lens is free of water droplets just before you snap the picture.

Figure 6.23 Glare streaking in

Figure 6.24 Glare spots

Getting the Blues (and the Yellows, Greens, and Pinks)

When your prints seem to show a bit of a color cast—such as being overly blue, green, or red—this is likely the fault of the photofinishing lab. If only one or a few prints are this way, perhaps you shot in a strange-colored light. Either way, the lab should be able to correct the print by compensating and adding another color. Of course, if the problem is not the lab's fault, you may be asked to pay for the reprint.

Skin tones are an especially good indicator as to whether or not your photo is suffering from a color imbalance. Even if the rest of the photo looks natural, people in it may look like green men from Mars. When healthy, happy people look green, blue, or red, take the picture back to the lab and ask them to correct the color.

Seeing Double

This problem occurs when the film does not advance properly in the camera; after you take one shot, instead of moving along to the next frame of film, it just stays there. One image is exposed onto the other, resulting in a muddled mess of partially transparent objects.

Figure 6.25 Double exposure

Although many photographers purposely experiment with such multiple exposures, the effect is more often accidental and unwanted. If you use a typical point and shoot, this problem is less likely to occur, as modern film-advancing technology is pretty sophisticated. If you are using an older manual camera, make sure your film is securely loaded into the camera. Then each time you advance the film, watch the film winder turn, indicating that the film is advancing.

If you are using a relatively modern camera and still get double exposures, take your camera to a repair professional and ask for an estimate.

Exposure Problems When Shooting Slides or Digitally

When shooting slides or digital images, symptoms of exposure problems often show up as the reverse of the symptoms you see when shooting negative print film.

For example, if you hand in a whole roll of slide film for processing before it has actually been shot, the film will look black instead of a clear brown color. A hair or dust on a slide will also be black instead of white. A severely underexposed slide will look black. Although an underexposed negative could also produce a black print, most machines and people in a photofinishing lab will try to lighten the print until it looks grainy and faint.

Also, with slides, you cannot ask the lab to redo images that are too yellow or too blue, for example. Because you are working directly with the film, the slide is all you get. If you order a print to be made from the slide, of course, you can have that print color corrected however you see fit.

When shooting digitally, exposure problems can easily be corrected using your computer.

TURNING PROBLEMS INTO OPPORTUNITIES

Now that you are aware of a few common problems photographers can face, from blur to compositional problems to errors in exposure, you are ready to get out and make a few mistakes of your own. As long as you learn from these mistakes, each one will be a stepping-stone to getting winning images all the time.

As you have more fun and success, you may want to increase your understanding of the art of photography. You may feel like trying something new with your camera from time to time. Lucky for you, the next chapter is devoted to just that: taking your photographic hobby to the next level.

Taking It to the
Next Level

The more you learn about taking pictures, the more you will want to try exploring new avenues of the art. Fortunately, photography is a never-ending journey; the creative options are limitless.

If you are wondering where to go after starting your new hobby, this chapter will introduce you to a few of the possible steps you can take next. You might, for example, buy a scanner or a digital camera so you can start experimenting with electronic imaging. If you already own and use a digital camera and have yet to learn all the cool things you can do with digital images, you might wonder what all the hype is about. In fact, what you can do with digital images will amaze you.

Others may find more satisfaction in learning how to develop their own film and make their own prints in a darkroom. Still others will find their calling in trying creative endeavors such as scrapbooking, hand-coloring black and white photos, and making Polaroid image transfers. If you have been thinking about going to school, joining a photo workshop, or taking a course in photography, the final section of this chapter will briefly preview what's available.

Now that you've mastered the basics of the art of photography, let's go a step beyond and explore what else your new hobby offers. First, we will go down memory-chip lane and look into the world of digital imaging.

GOING DIGITAL

To take part in the currently raging digital imaging party, you need either of two items: 1) a digital camera to capture your images or 2) access to a scanner so you can translate your film-based photos into an electronic format.

The party does not stop the moment you get your images into a digital format. You need a few more items in order to do something with the images. First, you will want a good image-editing program so you can resize, crop, rotate, or make other changes to your photos. To produce your own prints, you'll need either a digitally equipped photo lab or your own printer.

Figure 7.1 Hard drive. Digital pictures are stored on compact memory cards, CD-ROM disks, and computer storage devices such as this.

If you are considering digital photography, feeling comfortable around computers is a plus but is not required.

Choosing and Using a Good Digital Camera

The easiest and most convenient way to get into digital imaging is to buy a digital camera. By choosing one of the many simple point and shoot versions on the market, you can quickly begin taking digital pictures. Review chapter 2, "Buyer's Guide," if you are thinking about buying a digital camera.

These simple point and shoot versions, however, do not offer much creative control. You are a bit at the mercy of the camera's automatic features.

For those who like the thought of using a digital camera but need as much creative control as they can get, "prosumer" digital cameras may do just the trick. These digital cameras are designed for photographers who need to be able to control such factors as aperture and shutter speed. High-end models in the Nikon Coolpix series or the Olympus C series give photographers this kind of creative control but generally cost a bit more. Even more expensive digital SLR cameras, such as the Canon D30 or the Nikon D1, combine the cool features of digital imaging with the advantages of an SLR. These cameras allow you to change lenses, take pictures quickly, and use sophisticated external lighting set-ups—to the tune of a few thousand dollars.

If you don't already have a digital camera, if the cost is prohibitive, or if you just prefer shooting with film, you can still enjoy the world of digital imaging. You simply need to get your images scanned.

Scanning and Printing, at the Lab or on Your Own

You need not do your own scanning. Many photo labs now offer scanning services. Most of these labs will also happily print your digital images on specialty papers or with exclusive, artistic processes—all for a fee, of course.

Those who do feel comfortable with higher technology can enjoy scanning and printing at home and save money that they would have spent at the photo lab. Modern ink-jet printers are so good that almost anyone can print photo-quality images from their own computer. Good scanners are relatively expensive, but for photographers who do a lot of imaging, they can be a reasonable investment.

Photoshop and Image-Editing Programs

Many programs available nowadays are geared for beginning digital imaging buffs. In addition to their popular, expensive, and challenging Photoshop software, Adobe also makes an excellent byte-size version called Photoshop Ele-

ments. Others image-editing options are MGI PhotoSuite, PhotoImpact, PhotoDraw, and many more.

It's true: becoming familiar with the functions and tools of any software program takes time. However, that should not stop anyone from getting into the digital image manipulation. Using image-editing software opens up so many doors that you'll be amply rewarded for the amount of work you put into learning them. Besides, nothing about them is so difficult that a little practice, a good book, and a lot of inspiration can't overcome.

Figure 7.2 Circuit board in space. I used Adobe Photoshop to make this composite of a close-up picture of a circuit board, one of NASA's images of the planet Earth, and a background of stars made with a combination of software effects.

Filters, Composites, and Cloning— What Is a Boy (or Girl) to Do?

With a digital imaging program, you can easily play with the many ways you can change your images. You can crop, rotate, sharpen, and add text. You can combine two or more pictures into a new composite picture. You can cut out distracting elements that slipped into your picture.

With a special function called cloning, you can take bits from one part of the image and apply them to other parts of the image. This is how many digital artists give models flawless skin. Other photographers like to use the cloning function to

Figure 7.3 Foul ball. I again worked with Photoshop to make this composite of a baseball park and a baseball, duplicating the ball several times to create the motion effect.

remove telephone poles and wires from natural landscape compositions.

With the click of a button, you can also add interesting borders or make the entire picture look like a watercolor painting. Available filter effects are seemingly endless and will give you hours of creative options to explore.

DEVELOPING YOUR HOBBY

For photographers who use film (as opposed to digital photographers), a darkroom can add a whole new dimension to their hobby. Like manipulating digital images, though, developing photos can eat up a lot of time.

Yet it is enthralling to watch an image appear, seemingly out of nowhere. Darkroom work is quite simple, and the creative opportunities are many. You can print your pictures to look exactly as you think they should appear. You are no longer dependent upon a person or machine at the photo lab to make printing decisions and judgment calls. You alone really *know* how light or dark the scene was and what you had in mind when shooting it. Entering the darkroom adds another layer of artistic potential to your photographic hobby.

Keep two factors in mind, though. First, many similar effects and processes can now be achieved digitally, in the "digital darkroom" of your computer. A digital solution can cost more, but such software work can be as engaging as film processing and allows you to stay away from stinky chemicals and the like.

Second, keep in mind that color processing is very difficult. Doing your own developing and printing is much easier when you stick to black and white darkroom work. If you prefer color prints, you might want to continue taking your film to a photo lab or have it scanned so you can process and print it digitally. If you love monochrome (black and white) images, though, the darkroom may be the place for you.

It's Magic

Like many people, you might find great joy in the magic that happens when developing images in the darkroom. You get to be something of a wizard, making images appear—seemingly out of thin air! Most of us take developing for granted but begin appreciating the magic and mystery of the art when we learn what actually happens.

Variety: A Whole New Layer of Creative Options

Another huge joy in developing your own work is the flexibility and artistic control you exert over your photographic prints. The same negative can be printed in an infinite number of ways, resulting in infinite variety in the prints. A single image can be made to look dark and broody, light and airy, or anywhere in between.

Fun Fact!

Ansel Adams, before turning to photography, was studying to become a concert pianist. He likened the making of photographic negatives to writing a musical composition, and the art of printing these negatives to a musical performance.

An Easy First Step: Processing Your Own Film

To develop your own black and white negative film, you need a special tank to put your film in, a few chemicals, a clock, and a dry (preferably dust-free) place to dry your film. That's it!

The only other trick is keeping your film in absolute darkness while you transfer it from camera to developing tank. You do not need a big, fancy darkroom for this; the task can be accomplished with the aid of a "darkbag." This accessory allows you to stick your hands into the bag without letting any light in

Figure 7.4 Preparing film for development. Photo by Chris Groenhout

Figure 7.5 Loading film onto a developing reel. Photo by Chris Groenhout

whatsoever. Without this, you could also use a bedroom or closet that is absolutely dark (night provides your best bet on getting 100 percent darkness).

Making Your Own Prints

Developing your own film will only get you so far. You will likely be unsatisfied sharing with your friends and family the negative images you produce. To get good prints from these negatives, you need either an enlarger or a scanner. An enlarger shines light through your negative. By adjusting the height, you can make larger or smaller size prints. Those into the digital alternatives might be interested in simply scanning their negatives directly into the computer.

If you are interested in setting up your own darkroom, take a look at one of the many good books on the subject. For a quick introduction, visit the online articles by Chris Groenhout, listed in the "Resources" section at the back of this book.

Whether you go with digital or film, every photographer is essentially an artist working with light. Is it any wonder, then, that so many photographers eventually build their own studios? Creating such an environment makes controlling your light and getting pictures to look exactly the way you want them to look all the easier. So let's take a peek at how this is done.

 ## SETTING UP YOUR OWN STUDIO

A studio provides the photographer with a controlled environment in which to shoot. It involves one or more special lighting devices, umbrellas, a handheld meter, and a back-

drop. Studios are often used for portraiture, still-life photos, and product shots (the kind of pictures you see in most mail-order catalogs).

Let's Shed Some Light on the Subject

The lights can be "strobes," which flash once while taking the picture. "Hotlights," on the other hand, provide continuous lighting and allow you to make long exposures but cause the subject to get really hot (thus the name). I'm sure you can imagine why hotlights are not ideal for taking pictures of subjects such as ice cream.

When shooting with strobes, your usual understanding of exposure—shutter speed and aperture—gets a new twist. Instead of fiddling exclusively with the creative controls on the camera, you get to control the studio environment as well. Because the light is within your immediate control, you gauge it with a handheld meter, seeing whether it falls within your desired range, and then adjust the position or intensity of the lights to meet your needs.

Most newbies are stymied by questions surrounding light placement, but this is much easier than it looks. Simply use the modeling lamps and pay attention to how the shadows and bright spots change. If you see a shadow on your backdrop, figure out which light is causing the problem and soften it by moving the light back or turning it down. If you have a digital camera or a Polaroid back (a special accessory that can be attached to the back of many cameras), you can preview your exposure level before shooting with film.

Doing a Background Check

Backdrops provide a simple way to minimize clutter, eliminate distracting elements, and allow all attention to focus on your subject. You can purchase excellent muslin, canvas, or polyblend backdrops, but they can be pricey. Alternatives include making your own—as long as you feel comfortable working with fabrics and the occasional paint or dye. An-

other option is using special seamless paper backdrops, which are available at professional-level camera stores.

SCRAPBOOKING, CREATIVE COLORING, AND POLAROID TRANSFERS

People have come up with many creative ways to deal with photos after they are taken. Some offer an artistic way to present favorite images, along with other mementos and souvenirs. Others allow you to exercise the creative side of the mind while coloring black and white images or making Polaroid manipulations out of color slides.

Let's first look at what you can do with scrapbooking.

Scrapbooking, the Latest Rage

What could be more fun than combining your great pictures with the stories they illustrate? Scrapbooking offers an exciting way to do just that: put your pictures together with your words (along with other creative decorations) into one big, artistic expression.

Talk about hobbies taking the world by storm! Go into almost any craft shop and you should be able to learn all about scrapbooking. You might even be able to take a class there. If not, then look for a local scrapbooking store or visit one of the many Web sites on the subject.

Figure 7.6 An example of a scrapbook

To help you make scrapbooks, all sorts of accessories, templates, and decorations for your album ideas are available. You can find special photo cutters that will slice and dice your picture into circles, stars, hearts, squares, or whatever other shapes you might like. You can add clip-art items or draw around your

pictures with pens of all sizes, colors, and textures. If you love playing with doodads and surrounding yourself with art project materials, you will love scrapbooking.

What's more, you need not be especially creative to enjoy the art. With so many tools and ideas available to help scrapbookers, this craft is instantly available and enjoyable to anyone.

The bottom line of enjoying the art of scrapbooking is simply combining your pictures with your words. You don't need all the frills, bells, and whistles. You can start by simply getting a good quality album, placing your photos, and writing down descriptive details. Write whatever comes to mind when you recall the subjects or the events that inspired you to take the pictures.

Your written description doesn't have to be thorough or perfect. Even if you do not consider yourself a good writer, simply jotting something down will help you remember more about those special times. Writing the stories next to each photo will enrich your memory of the joys you experienced while taking them.

For a few good places to start getting ideas about scrapbooking, check the resources listed in the back of this book.

Hand-Coloring Black and White Prints

With special colored pencils, you can partially tone individual areas of a black and white print. This can add a creative touch to your images and lend them a new degree of charm.

Hand-coloring is not hard. You may need to coat your black and white print with a special oil, but other than that, it is as simple as getting out your print and starting to color. If you are interested in exploring this art form, look for Marshall's brand of pencils and coloring kits and visit Handcolor.com.

Digital imaging enthusiasts will be happy to know that you can also achieve a similar effect in many image-editing software programs.

Polaroid Transfers

If you shoot slides, you can have a lot of fun making wildly manipulated Polaroid image transfers and emulsion transfers out of them. Using a Daylab or similar device, you essentially take a Polaroid picture of one of your favorite slides. Then to get an image transfer, peel apart the Polaroid before the chemicals have enough time to fully develop. Press the

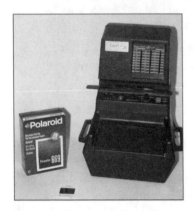

Figure 7.7 Daylab and pack of Polaroid film

dye-laden negative into a receptive material such as watercolor paper, and, after a minute or two, you have an image transfer. You get varying results depending upon the paper you use, the amount of time you let the Polaroid develop, and the manner in which you apply the chemicals. This creates an image with very unusual colors and texture.

For emulsion transfers, instead of prematurely peeling apart the Polaroid, let it fully develop. Then, using a pan of hot water, cook the Polaroid print for a few minutes until the emulsion loosens. In a matter of minutes, you have a flexible, gelatinous material with your

Figure 7.8 Polaroid emulsion transfer of butterfly close-up photo

photo on it. You can then carefully apply this delicate image to different kinds of paper or other materials. The surface does not even have to be flat. An extra level of creativity comes into the picture because you can purposely rip, fold, stretch, or shrink certain parts of your picture.

Like most art projects, making Polaroid image or emulsion transfers is a lot of fun, and you end up creating totally new versions of your favorite images. For more information, check out Kathleen Carr's book listed in Resources.

BACK TO SCHOOL: TAKING A CLASS OR WORKSHOP

If you are considering a little more formal training in the art of photography, consider these options:

- Take a class at your local high school, trade school, community college, or online at a photography Web site.
- Enroll at a long-term formal institute that specializes in photography.
- Participate in an on-location workshop.

Local or Online Classes: A Great Place to Start

If you are considering further education in photography, taking a class at a local school or via a photo Web site is an excellent idea. Prices for such classes are much less than for professional schools and workshops, instruction is typically hands-on, and you get to meet more people who share your interest in photography.

Some classes will include instruction on the art of taking pictures, but most center around developing and printing. If you are interested in darkroom work, dive into such a class. It might just lead you to another deeply satisfying hobby.

Professional Institutes and Schools

If you are really serious about photography, perhaps considering it as a career, what could be better than investing every waking moment in the art? A long-term, two- or four-year academy might be just your ticket.

Be aware, however, that you do not need a degree to become a professional photographer. No one ever asks to see your degree before allowing you to photograph them. The major benefit of attending such a university-like environment is the impact it will have on your level of confidence. The piece of paper is important but only as a symbol of all you have mastered. At such a school, you will learn a heck of a lot about photography.

On-Location Photo Workshops

My favorite way to keep improving my understanding of photography is by getting out into the field and practicing as much as possible. Shooting and studying the results can take me a long way, but when I feel stumped and in need of a boost, I look into taking a photo workshop.

Photo workshops offer one of the best ways to learn the ins and out of photographic technique. With the help of a master photographer, you can develop your skills, increase your understanding, and have a great time in the process.

Photo workshops are not for everyone. First of all, workshops can cost a lot. This is due largely to the fact that master photographers typically limit their group sizes to, say, ten or twenty people. Whereas other teachers may juggle hundreds of students, the photography instructor needs time and energy to give you his personal attention, critiques, and advice.

Furthermore, a photo workshop can be an adventure. Depending on the location, your course, and your assignments, you could be taking on some intense experiences. While attending many workshops, you may have to forget about air-conditioning and eating at fancy four-star restaurants. You're likely to consider yourself lucky if you get to scarf down a piece of pizza before going to bed. You may well be having so much fun shooting into the late hours, though, that you won't care about what you're missing.

Of course, many photo workshops offer a much more relaxed, even pampered experience. Either way you go, you will have a blast. What is more, you will pick up a wealth of new ideas and technical tips.

So there you have it. You can take this new hobby almost anywhere you want. With digital imaging on one end of the spectrum and film developing on the other, you have many paths from which to choose. Whatever way you decide to go, I wish you a long and enjoyable adventure, shooting as many great pictures as you can along the way.

Now, does anybody have any questions?

Questions and Answers

The following questions and answers represent the majority of topics that perplex budding photographers. Some point back to topics covered in previous chapters. Others cover totally new topics. If you happen to run into one of the typical stumbling blocks, these answers should quickly get you back on track.

What Should I Take Pictures Of?

Many people fall in love with photography long before they are blessed with an idea of what subjects they most like to shoot. The question is most often asked with the word *should* given all too much weight, as if there is one correct answer to this question for everybody. If you are having trouble deciding what subjects to photograph, you are likely to get a few ideas from the following three guidelines.

> *A lot of people ask me if I were shipwrecked, and could only have one book, what would it be? I always say* How to Build a Boat.
>
> —Steven Wright, comedian

1. Do Your Homework
(Or at Least Look at the Pictures)

Photographers get ideas and learn a lot about photography by continually studying the work of other photographers.

Look at pictures in magazines, photo galleries on the Web, or stock photography catalogs to get good ideas of the subjects you would most enjoy shooting. If you like looking at pictures of animals, for example, the odds are high that you

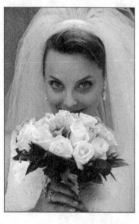

will feel inspired and excited when trying to photograph pets or wildlife. If you most enjoy leafing through *People* or *Bride* magazines, perhaps you would like to shoot portraits and weddings. To test the waters, ask a friend to model for you so you can see firsthand how much you enjoy photographing people.

Stock photography catalogs are thick booklets filled to the brim with images. Advertisers systematically peruse these catalogs to find the photos that will best illustrate their magazine ads, billboards, and the like. Even if you don't plan to become a professional stock photographer, these catalogs offer a great wealth of subject ideas. If you

Figure 8.1 Close-up portrait of bride. People who like going to weddings often love photographing them.

know someone in the publishing or advertising industries, ask him or her if you can borrow a few of these booklets.

As you look through these magazines and catalogs, ask yourself why each photo interests you and how you might try to go about shooting the same subject in your own way. Make a list of potential places, people, or things that you would like to try shooting. Then pick one subject from the list and begin practicing with your camera.

2. Shoot What You Love

It's natural to treat the things you especially appreciate and cherish with the most care, attention, and inspiration. Like-

wise, the visual subjects you love, the subjects that matter most to you, often make the best photographs.

What do you love the most? Is it your family, your dog, your weekly hikes, or your work? If you love your children more than anything, shoot rolls and rolls of film of them (I doubt this will challenge any parent or grandparent!). If you are a college student and love dorm life—staying up late with friends, hanging out in your room, playing foosball—then by all means, take pictures while you are enjoying these times. Whatever gets you going and inspires you most will offer the best opportunities for you to hone your photographic technique.

3. Shoot What You Know

Along with photographing what you find most inspiring, shoot the subjects you are most familiar with. Love and knowledge go hand in hand. You will find it easiest to take great pictures when you know the ins and outs of your subject. For example, you may be an expert on a subject such as one of these:

- The times and seasons of the environment around you—the sunrise and sunset, the turning of the leaves, your neighborhood just after a heavy rain
- The biology and social habits of the animals you photograph
- The sleeping and eating cycles of your nine-month-old baby

You can take this principle one step further and shoot what your friends best understand. If a friend works on a farm, in a scientific lab, or at a local state park and you want to get photos in such an environment, ask if you can tag along sometime to take pictures. Lean on the knowledge of others to expand your repertoire of photographic subjects.

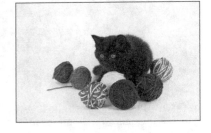

Figure 8.2 Crouching tiger, hidden kitten

Write down a list of whatever subject ideas you come up with. Even if you do not end up photographing exactly what you plan, this list will give you the ideas you need to keep going should you feel blocked or uninspired.

The bottom line on figuring out what to photograph is this: Do whatever it takes to get out shooting, regardless of what you think you *should* photograph. The key is finding subjects that inspire you to take the camera out, whether on a walk in the sunshine, a ride in your car, or a visit to a museum.

Fun Fact!

After convincing his parents to go on vacation to Yosemite National Park when he was just a kid, Ansel Adams fell so in love with the area that he returned every year for the rest of his life.

Where Should I Take Pictures?

Another problem many beginners face is the feeling that the area in which they live offers nothing good to photograph. The fact of the matter is that almost any location offers ample material for photographs. Great photographers have proven this, some by making masterpieces out in their own back yard, while others have worked wonders in the most urban areas.

Figure 8.3 Crocodile photographed at the San Diego Zoo in California. You do not need to go on a wildlife safari to get great pictures of such animals.

If you have the means to travel, you can find photography "hot spots" anywhere from the Southwest United States to Europe, Asia, or Africa. But you need not travel far distances to find

great photos. Simply go to your nearest zoo and you'll see plenty of good photo ops. Anywhere you feel inspired by what is around you, you will be able to take great pictures.

How Do I Tell the Difference Between a Good Picture and a Bad Picture?

Good question. One man's "good" picture is another's "bad" picture. Some photos are considered great because they successfully convey a concept or emotion. Some are praised because they capture perfectly a particular moment in history or tell an interesting story of their own. Still others are applauded for capturing and conveying the beauty of a person, fashion, endangered species, or ecosystem.

Regardless of a picture's purpose and subject matter, most people agree that the photo should show a degree of clarity, unless the photographer obviously intended the opposite. The photo should not be so dark that it is difficult to make it out. Nor should it look muddy or obscured, two symptoms of underexposure. A clean, simple, or well-orchestrated composition is always appreciated. This is just the beginning of a complete answer to this question; you can find other clues throughout the book and in the books listed in the "Resources" section.

> **Fun Fact!**
> The most requested photo from the National Archives is a shot of Elvis Presley offering his services as a drug enforcement agent to President Nixon.

Why Do Things Look So Small and Far Away in My Pictures?

Whether you are taking a picture of a bald eagle or your kids playing soccer, you may be unpleasantly surprised by how small these subjects look in the prints you get back from the lab. Although they appeared big enough to your naked eye during shooting, they look miniscule in the photographs.

Your camera and lens may not feature enough telephoto or zooming power. Try to fill the frame every time you take a picture. Use your telephoto lens or, if necessary, walk as close as you can to your subject. If space restrictions keep you from walking close enough, the best solution is using a camera with a more powerful lens.

What Kind of Camera Should I Get?

There are too many variables and camera models for me to recommend one "best" camera. See the section in chapter 2 on buying cameras for more guidance on this issue.

What Kind of Film Should I Use?

Most beginning photographers feel stymied when it comes to choosing a film. You might ask, "How can I possibly know what subjects and scenes I will be shooting by the time I actually get around to shooting the film?" You could end up taking pictures of your family, of dim corridors in some ancient cathedral, and of a spectacular sunset—all within the span of one roll of film. Even if you know exactly what you will be shooting, conditions can change in the blink of an eye.

The true answer to this dilemma is that film matters . . . but not enough to warrant all the worry it generates. Film, fortunately, is less of a troublemaker than most people think. As long as you keep a few ideas in mind when you purchase film, such as those found in chapter 2, "Buyer's Guide," you need not worry much about making the wrong choice. Especially when you shoot regular color print film (which most people use), you will find the results satisfactory in a majority of situations. Any common problems you see will more likely result from an inferior camera lens, improper exposure, faulty focusing, or a lack of good technique.

All the same, if you are still stuck on this question, start with a roll of 400-speed color print film such as those made by Kodak or Fuji. 400 is a nice safe speed and will give you quality prints in the standard 4" × 6" size.

Must I Always Choose Prints or Slides Before I Shoot?

You might wonder, "Can't I just bring a finished roll in and ask for slides instead of prints?" Many labs *can* give you slides from print film and prints from slide film. However, these services are so expensive that you will probably want to use them for only one picture at a time rather than for a whole roll. Also, you often end up with less quality in the results. Generally, choosing the appropriate film before you go out shooting is best. If you want regular 4" × 6" snapshots, choose a good roll of color print (negative) film. If you want slides, choose a good roll of slide film, which will be clearly marked as "color positives" or "transparencies." The easiest slide film to have developed is that which says it should be processed in "E-6" chemicals.

What If I Accidentally Shot with Slides When I Meant to Use Negatives?

As mentioned in the previous answer, photo labs can help you out of many film-related jams. If you accidentally put slide film in when you mean to put in a roll of regular film, or vice versa, you can often salvage the situation and get prints from slides or slides from negatives. The quality may not be as good, however, and you'll likely end up paying much more for developing services.

Will X Rays Hurt My Film?

When traveling, store film in your carry-on rather than checked luggage whenever possible. The scanners used for carry-on luggage are usually a lot more photographer-friendly than are those used for checked luggage. Also, the consensus is that the higher speed films (ISO 800 and above) are more vulnerable than slow-speed films. I know professional photographers who never worry about this because they shoot slow-speed film exclusively and have yet to experience problems with X rays.

All the same, to be extra safe, I ask the security agents to hand-check my film instead of sending it through the machine

whenever regulations allow. To make this process go as smoothly as possible, I remove each roll of film from its cardboard box and inner container (if it is a black, opaque container. Clear containers are okay; the security agents simply need to be able to see each roll). I then store the rolls of film together in a large, clear Ziplock baggie.

These steps will make the security inspection go as quickly as possible; instead of opening each individual container, agents will likely give your bag a visual inspection and let you pass.

Do I Really Need to Use a Tripod?

Getting some people to use a tripod is like pulling teeth. The benefits of tripods, however, far outweigh their inconveniences. Tripods are not just for self-portraits. They are the ultimate anti-camera-shake device, providing a stable

support when the light is low. Furthermore, they allow you to get cool special effects only available with long, slow exposure times. As long as your camera can take long exposures, using a tripod will allow you to capture night scenes, fireworks, and other interesting subjects. Combining the use of a tripod with the self-timer mode or remote control will expand your photographic repertoire enormously.

If you absolutely must travel light and cannot justify carrying a regular tripod, or if tripods are impractical or prohibited where you are shooting, you can buy a mini tripod that's as small as your hand and incredibly light.

Figure 8.4 SLR camera on a tripod

What Are Filters and Should I Buy Them for My Camera?

Filters are special pieces of glass you can place in front of your lens to create interesting effects.

Still Don't Want to Buy a Tripod? Try Making Your Own

As a substitute for a tripod, you can make your own "isometric stabilizer" out of nylon rope and a ¼" bolt. As shown below, you can attach this to your camera when you need a little extra stability when shooting in dim lighting conditions.

1. Buy a looped ¼" bolt and a length of 2-mm nylon rope as long as your height.

2. Insert the bolt into the tripod socket in the bottom of your camera and attach the rope.

3. Step on one end and pull up on your camera as you take a low-light picture.

This homemade device will give you a bit more stability whenever the use of a tripod would be impractical, impossible, or just not allowed. As always, shoot an extra shot or two of your favorite scenes to make sure you get at least one sharp one.

If you shoot with a simple point and shoot camera, you may find working with filters difficult. Most of these compact cameras do not feature threads into which you can screw filters in place. If your camera does have these threads, be sure you buy the correct size filter. Bring your camera to the store if you are unsure which size to get.

Even if you can use filters, though, you will likely need only two in particular: a polarizer and a UV or Skylight filter. These two filters will enable you to:

Figure 8.5 Filters

- Make deep blue skies and pure white clouds.
- Reduce glare and eliminate reflections.
- Protect your lens from scratches.

Other good filters allow you to produce artistic effects, such as washing an entire scene in a particular color or creating a soft-focus effect for pleasing portraits. But such other filters are by no means required.

> ## Helpful Hint
>
> Try shooting your scene with a homemade filter. Simply aim your camera through textured glass, a rain-covered window, a screen door, or even a mesh fabric like pantyhose. Experiment with various makeshift filters for creative results and more enjoyable shooting.

One problem with filters is that they often take the attention of the would-be photographer away from more important principles. When budding photographers should be thinking about basics, such as focus and exposure, they are tempted to think of filters as the solution to any and every photo problem. Filters are no magic cure-all; they will not instantly make anyone a better photographer. Resist the temptation to spend your money on filters until you have mastered the tips in this book and are ready to try something new.

Should I Buy a Camera Bag?

Camera bags offer wonderful, custom-fit solutions for photographers. With a good bag or case, each expensive element or accessory will remain safely tucked away. Point and shoot users can get compact, simple camera bags with just enough room to carry an extra battery and film. SLR users can buy anything from multicompartment bags to waterproof hard cases to photo backpacks or shoulder bags.

Unfortunately, thieves love to steal cameras. Along with purses, camera bags are among the easiest to spot and most

rewarding targets. To reduce the likelihood of theft, keep your camera bag less visible or disguise it by carrying your camera in something other than a typical brand-name photo bag (or cover up the logo, at least). Fashion a carrying case for yourself out of a lunch pail, cooler, or small suitcase. You can buy foam padding at a local arts and craft shop to add a protective custom. Camera backpacks, especially when disguised as a traditional daypack, are great for those with lots of gear. Backpacks also have the advantage of distributing your burden evenly across your back. Shoulder bags offer easier access to your camera but may be more cumbersome.

I am always surprised when I see several cameras, a gaggle of lenses, filters, meters, et cetera, rattling around in a soft bag with a complement of refuse and dust.

—Ansel Adams

Should I Buy a Digital Camera Yet?

This hot question of the day involves too many variables to make a general recommendation. I will simply say two things:

1. I love my digital camera.

2. If you have extra cash to spend, own a computer and a printer, and are pretty sure you will benefit from the immediacy of a digital camera, I recommend you consider buying one. If, however, this does not describe you, or if you are most interested in developing your understanding of photographic technique, you will likely benefit more by spending your money on something else—such as a 35mm SLR. Read chapter 2, "Buyer's Guide," for a much more thorough answer to this question.

Did I Get a Good Deal on the Camera/Lens/Accessory I Just Bought?

It may be too late to return your purchase, but read chapter 2, "Buyer's Guide," to learn more about whether or not the equipment you bought is the best fit. See the BetterPhoto.com Web site or the resellers recommended in the back of this book for specific pricing information.

Should I Buy a New Camera or Repair My Broken One?

First, go to the camera store and buy a new battery for your camera. Cameras are frequently deemed dead when all they need is some electricity. Unless you dropped the camera, replacing the battery may be all the "repair" your camera needs.

If your camera was dropped or the battery solution does not correct the problem, you may want to take it to a camera store that handles repairs. Keep in mind that repairs are often so expensive that getting your camera fixed may not be worth the repair cost. If you paid only about $100 to $200 for your camera before it ceased to operate correctly, you may be wise to simply scrap it and buy a new one. That's because you will likely spend nearly as much on a repair as you'd pay for a new camera. If you are unsure whether repair will be cost-effective, ask for a written estimate. If the estimate seems too high, you should be able to decline the repairs and put your money into a new camera. You might be charged for diagnosis or shipping, but this relatively small fee will do less damage to your wallet than the cost of an all-out repair.

How Do I Pose People?

The only arrangement you're likely to avoid is composing people as though they are on a Twister mat. Other than that, almost anything goes. You may prefer arranging taller people in the back so that shorter ones don't get blocked. You can also arrange people in a kind of pyramid of height, with the tallest person in the center. Most important, make people feel comfortable and at home. Usually, better portraits come from letting your subjects pose themselves natu-

rally rather than from your directing them into one position or another.

How Do I Shoot Black and White?

Buy a roll of black and white film, pop it in your camera, and click away. Other than the roll of black and white film, you do not need anything special to experiment with this kind of photography. What's more, I highly encourage you to try it; you can learn a lot about the "graphic" part of "photographic" by shooting with black and white.

If you do use true black and white film (which can create the prettiest results), you will have to take your film into a special custom lab (or have it sent to a special lab) for processing. This can cost you a bit more and keep you waiting longer to get your prints back. In fact, unless you specifically request prints, you may only get back one big 8" × 10" piece of photo paper with a bunch of tiny images on it. Called a *contact sheet*, this set of images is designed to enable you to decide which images are worth printing. This will help you save money in the long run (especially because black and white prints can be much more expensive than color prints).

To avoid this unnecessary expense and delay, you can buy a certain kind of black and white film that you can have developed at a regular color photo lab. This special film (examples include Ilford XP-2 and Kodak T-Max T400 CN) captures black and white information but can be processed in standard C-41 color chemicals. I'll warn you, though, that this kind of film can produce slightly toned or sepia-like prints (you know, the old-fashioned-looking photos). Try it out; you may end up liking it. Most pros, however, prefer true black and white film to these C-41 versions.

Why Would I Want to Shoot Black and White?

Black and white can create a classic and elegant look. Many brides, for example, find that black and white adds a special romantic quality to their wedding album. You can often

make an amazing black and white out of a shot that would be drab in color. Also, when learning the art of photography, the simplicity of black and white helps you focus on other important elements rather than get distracted by color. Lastly, if you would like to eventually do your own darkroom work, black and white opens up a world of magic and fun and is much easier to develop than color film.

How Do I Shoot Lightning?

Very carefully (see answer to next question).

How Do I Shoot Fireworks?

A little less carefully. In fact, shooting fireworks or lightning is pretty easy, as long as you have a tripod and a camera that lets you take long exposures. If I had only a point and shoot camera, I would not even try shooting these subjects; at best, it would be frustrating. I recommend you attempt this only if you have a camera with an open-ended "B" exposure mode, one that allows you to hold the camera shutter open for as long as you darn well please.

To shoot lightning bolts, point your camera in the general direction of the bolts you have been seeing and open the shutter until you see the next lightning bolt strike. You may also be able to use a special accessory called a *slave*, which is designed to take the picture the exact moment lightning strikes. This is particularly helpful if you are trying to photograph lightning during the day, when leaving the shutter open for a long time would result in a severely overexposed picture.

The principles behind taking firework photos are similar to shooting lightning. To get the best results, load up your camera with a slow-speed film (such as Kodak Gold 100). Then set your camera on a tripod and use a cable, remote, or other hands-free device to fire the shutter. Every time a missile goes up, click open the shutter and hold it open until the bursts stop. Experiment with various exposure times and enjoy the fireworks as you shoot.

How Do I Get Better Shots at Outdoor Sporting Events?

Most likely, the best way to immediately improve your outdoor sports photos is to use a camera with a more powerful zoom or telephoto lens. With such a camera, you can zoom in and conscientiously work to fill the frame with your favorite player or players.

If you do use a telephoto lens or a strong zoom, you will probably want to use a faster film speed, such as ISO 400 or even 800. Using a slower film speed in such a zoomed-out, telephoto situation will more likely result in blurry photos.

How Do I Shoot Indoor Sporting Events and Concerts?

Shoot indoor sporting events and concerts with a fast film and use a tripod or monopod (basically a one-legged tripod). Turn off your flash because it may distract the players or performers—and most likely won't reach your subject, anyway. Try to make the most of the available lighting in the arena or concert hall.

Sporting events are usually brighter than concerts, so you may be able to shoot without a tripod using a faster film such as ISO 400 or 800. Whether it will work depends on the amount of light being flooded into the stadium or field.

How Do I Shoot Close-Ups of Flowers, Jewelry, Coins, and Small Objects?

Macro photography requires a special mode, lens, or lens accessory. If you are using a point and shoot, check your manual to see whether your camera features a macro mode.

When shooting macro, you usually need to keep from getting too close to your subject. The lens will often have a minimum focusing distance, and your pictures will come out blurry if you are closer to your subject than this minimum distance. Sometimes, if you get too close, the camera will not let you take the pictures at all.

How Do I Get That Flowing Effect with Waterfalls and Rivers?

For these long-exposure effects, you need a tripod. Slow film (such as 100-speed) works best. Low light conditions will further help you by forcing your shutter to remain open for a longer period of time. If you have a slow film in

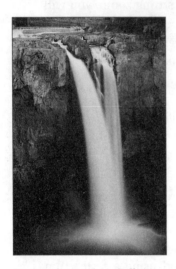

Figure 8.6 Snoqualmie Falls in Washington, shot with a long, slow shutter speed and camera mounted securely on a tripod

your camera and relatively low lighting conditions, you can use a dark filter (such as a polarizer or a neutral density filter) to block out more light and thus slow the shutter speed down even more. Neutral density filters, made specifically for this purpose, are simply pieces of glass that are uniformly darkened. Polarizers are generally used for another purpose—to eliminate glare—but because they too are dark, polarizers can also be used to slow down shutter speed. This open shutter allows more time to pass while the camera is actually taking the picture, resulting in the soft, flowing effect.

How Do I Get That Effect Where Car Lights Stream Off into the Distance at Night?

Same as shooting waterfalls and rivers (see previous question) except that because you are shooting at night, you should have no problem getting a slow shutter speed. Fifteen- or 30-second shutter speeds will give you the longest streaks, but anything longer than a few seconds will create similar effects. As long as your camera features such slow shutter speeds, you should be able to combine it with a tripod and some slow film to get such long-exposure special effects.

How Do I Shoot Silhouettes?

If your camera allows you to lock your exposure, shooting silhouettes is easy. Simply fill most of your viewfinder with the background of your intended scene. For instance, if you are doing a silhouette of a person in front of a sunset, temporarily fill the frame with the sunset only. Then lock your exposure. (With most cameras that feature this function, you lock your exposure by pressing the shutter button down halfway.) With the exposure levels locked, recompose your scene until your subject is where you want it and then take the picture.

Fun Fact!

Silhouettes are named after a French minister of finance who had a reputation for being tight with money, as silhouettes are a tight outline around a subject.

How Do I Create Soft Focus for Portraits or Make the Background Blurry?

Portraits really pop out in a stunningly beautiful way when the background is not distracting. Professional photographers often create this soft background effect by focusing sharply on the subject and letting the rest of the picture softly blur.

You need either a special "Portrait" mode, which will encourage your camera to create this effect (but you won't know whether you succeeded until you get the prints back), or the ability to control depth of field. Depth of field is most directly related to aperture. Aperture is the size of the opening through which light enters the camera. If your camera allows you to set aperture, create a shallow depth

Helpful Hint

When shooting an outdoor portrait in direct sunshine, you will often find your subject's eyes lost in dark, shadowy eye sockets. To avoid this, try moving the subject under an awning, a tree, or another form of open shade.

of field by selecting a larger aperture. Usually this can be done with SLR cameras. For more on depth of field and aperture, consult "Best Books for Beginning Photographers" in the "Resources" section at the back of this book.

You can also emphasize this soft background effect by using a telephoto lens or long zoom setting. I find that a 100–110mm lens length works well for portraits.

How Do I Get Decent Photos on an Overcast or Rainy Day?

Here are a few suggestions for taking rainy-day photos:

- Do not include the sky in your photos.
- Take pictures of life in the rain (using a waterproof baggie or shower cap to protect your camera).
- Take portraits. For these, bright overcast can provide a very pleasing, soft light. It is actually much better than direct light for portraiture.
- Try shooting with black and white film. This often makes a better rainy-day picture.

How Do I Find the Best Photo Lab?

To find the best local labs, ask your friends where they go or look in the phone book under Photofinishing. Go to the lab, take a look around, and ask the employees a few questions to get an idea of the lab's standards.

First of all, find out whether they process film on-site or send it out to another lab. You are bound to get the best customer service from a lab that does the processing right on the premises.

Look to see whether they put all negatives in protective, plastic sleeves or simply let them float freely with the photos. Free-floating photos usually signal a lack of concern over your valuable assets.

Other good questions include these: Do you do spot retouching (to fix dust problems)? What is your redo rate (the percentage of prints sent back to the technician until they are perfectly printed)? What is your policy on reprints? The

more professional labs do spot retouching, don't mind doing an occasional reprint, and consistently redo a percentage of their prints to keep their quality of output high.

If you feel satisfied, do some test prints. Select a few shots and ask them to make reprints. If you like these, you can take in a roll and see how that goes.

Do Those Red-Eye Pens Really Work?

Yes. If you are careful and treat the eyes with a very light touch, you can minimize the red-eye problem with one of these pens. Be warned, though, that retouching around the eyes is very difficult and takes a careful, artistic touch. I recommend that you practice with the pen before working directly on your photo. Apply it in very small amounts, dabbing lightly. Each time you dab, the color will darken. Because you cannot erase what you've done, add color sparingly and frequently check your work.

How Should I Store My Film?

Film is considered a perishable—like the milk in your refrigerator in some ways. Film does have a peak date. After its "Develop By" date passes, the film becomes more and more likely to produce unnatural color shifts. You might, however, be able to get decent, if not great, shots from film months after the expiration date.

You can prolong the expiration date by keeping your film in a cool place. I like to keep mine in the crisper drawer of my refrigerator—*not* in the freezer. Even keeping film in the fridge requires that you pull it out an hour or so before you shoot it so that it has time to warm up properly. Moving it straight from the fridge to the camera can cause condensation problems, which can result in the film sticking to itself in the roll or in prints showing large, unseemly spots.

When buying film, especially online, make sure that it has not already passed its expiration date. Most important, don't shoot anything important with film that you are not 100 percent confident about. It's easy to pick up a new,

fresh roll of film, but it's impossible to go back in time to re-capture a past moment.

What Should I Do with All My Negatives and Prints?

I like to buy 8" × 10" plastic sleeves and use them to store my negatives and slides in three-ring binders. This allows me to keep all my original "source" images in one place. I can also mark the plastic sleeves with words and pointers that remind me later which photo is which.

Prints that I don't especially love (but still don't want to throw away) are stored in shoebox-sized containers, in case I come to like them more in the future. The better ones I put in photo albums, in frames, or on the wall; I figure that having a bunch of photos I never look at does me no good. By placing them in albums, I am more likely to review them than if I kept them in their original paper envelopes, stuffed into drawers throughout the house.

Why Does the Photo Lab Chop Off the Edges of Some Enlargements?

If all proportions remain constant, a 35mm film negative would naturally enlarge to an 8" × 12" image. Squeezing the same photo into the standard 8" × 10" frame size must result in either a greatly distorted picture or one with an inch trimmed off each end. To avoid becoming frustrated due to this issue, make sure you allow extra space on each end of your image when you take the photo. See figure 6.15 in chapter 6, "Troubleshooting," for an example of this problem.

I Lost My Manual. Where Can I Find a Replacement?

Many camera manufacturers offer manual replacement services online via their Web sites. If your camera maker doesn't, you might be able to find one at a pro camera shop; some shops keep a rag-tag box of old manuals on the premises for that very purpose.

Also, third-party publishers write guidebooks on specific cameras that at times far outshine the original camera manual. Look at the "Magic Lantern" series or, if you use a digital camera, the books by Denny Curtain to see if your camera has had such a guidebook written about it.

What Is the Difference Between a Telephoto and a Zoom?

A telephoto lens allows you to magnify subjects that are far away but does not allow you to change the level of magnification. A zoom allows you to either *zoom in* (get closer to far-away objects) or *zoom out* (get farther back from far-away objects and thus squeeze in more of the scene).

Is It Better to Zoom In or Simply Walk Closer to Your Subject?

When shooting portraits, zooming in (using the telephoto) is generally better than simply walking closer to your subject (staying with a wide-angle lens setting). If you want subjects to look their best, avoid getting close to them, as this will likely result in unpleasant distortion. This will also help make the background simpler and less distracting.

Also, zooming in seems to shorten the distance between the subject and the background. If you want to make something in the background bigger in relation to your subject, then zoom in. This is how some photographers are able to make the moon appear much larger than it actually is. They use an extreme telephoto lens and take a picture of the moon next to a cityscape. See figures 5.7 through 5.9 in chapter 5, "Putting It into Practice," for a series of examples that show how objects get bigger in the background.

If you are taking portraits in an especially beautiful place—under a blooming decorative cherry tree, for example—one of your goals might be to capture a bit of the surroundings along with the portrait. In this case, you might want to zoom out a bit so that some cherry tree blossoms

also show up in the picture. In this situation, including some background may actually enhance your portraits.

When taking a scenic picture with a person in it, I first try walking back to get in some background. Then, if I absolutely must, I zoom out a bit to get a wider angle.

If I am taking a picture of buildings, nature, or other subjects, I don't mind going wide-angle as much. In fact, I like it. To get a wacky, wild-angle distortion effect, I usually try to get as close as I can with the widest setting I can.

To get the effect you are after, shoot from as many different focal lengths as you can. When you strive for variety, you will have more to choose from and be able to clearly see the difference when using various focal lengths.

Glossary of Terms

35mm. The size of the film in most cameras. Other sizes include APS, which is slightly smaller than 35mm, and 16mm, a tiny film used in spy cameras. On the other end of the spectrum, sheets of film can be as large as 8" × 10" or more; such film is used in special large-format cameras such as the kind Ansel Adams used.

A. See Aperture Mode.

AE. Auto-Exposure. When the camera automatically sets the aperture and/or shutter speed to what it considers best for your particular lighting situation.

AF. See Autofocus.

AF Lock. Autofocus lock. A function that allows you to hold the focal point while you move the camera to recompose your photo. It also allows you to prefocus on a fast-moving subject, as a way to help you catch the right moment when shooting action shots.

APS. Advanced Photography System. With APS, you load film without ever having to touch the negatives, by simply popping a self-contained film cartridge into the camera. It gives you a choice of three picture sizes: regular, slightly wide, and panoramic.

Aperture. The size of the hole in the lens, which controls how much light gets into the camera.

Aperture Mode. Also called "aperture priority." On some cameras this represents the mode that automatically calculates shutter speed after you specify the aperture that you would like to use. Most point and shoots do not offer this option.

Autofocus. When the camera focuses for you, as opposed to manual focus—when you have to set the focus yourself.

AV. See Aperture Mode.

"B" Exposure Mode. A setting that lets you keep the shutter open as long as you like. This comes in handy when doing special effects such as fireworks, lightning, and streaking car brake lights at night.

Backlighting (Backlit). When the sun is in front of you, lighting your subjects from behind.

Bounce. Some flash units allow you to change the direction of light. If you have such a flash, directing the light toward the ceiling or wall so that it "bounces" off of that surface before illuminating your subject will cause the subject to be lit more softly.

Camera Shake. When the camera moves a little as you press down the button, causing the picture to come out blurry.

Candid. An unposed picture of a person or group of people. Candids are less formal and staged-looking than portraits.

Catchlights. Tiny reflections of light in the eyes of people or animals you are photographing.

Close Focusing Distance. The minimum distance you can get to a subject before the lens can no longer focus properly.

Close-ups. See Macro.

Composite. An image combining two or more photos.

Composition. Arrangement of everything in the photo. See chapter 3, "Better Photo Basics."

Contact Sheet. An 8" × 10" print that has film-size versions of all images on the roll. Most professional black and white labs offer this service as an alternative to individually printing each photo (which would end up being much more expensive); you instead choose the images from this contact sheet that you want to have printed.

Contrast. The difference between the bright areas of a photo and the dark. High contrast photos have very dark and very light areas in the same image. Low contrast has a more even-toned look.

Cropping. Cutting off the edges, either by moving in closer to your subject when you are taking the picture or by trimming off the edges of your finished photograph.

DOF. See Depth of Field.

Date Mode. See QD.

Darkbag. A black, cloth bag for photographers who develop their own film, allowing them to transfer negatives from the film canister to the developing chemicals in a light-tight environment.

Depth of Field. The range of things in a scene, from front to back, that remain sharp. Shallow depth of field means that only a limited area is in focus. A deep depth of field makes everything in the picture look sharp, from the closest to the farthest objects.

Developed. When a roll of film has been processed in chemicals to produce visible images, it has been developed.

Diffuser. Something that softens the light source. When using flash, this can be a little piece of semi-opaque plastic. You can also use your hand to block some of the light or, if you camera lets you, bounce it off the ceiling or a wall. Also, a diffuser may refer to a filter that softens focus.

Digital Camera. A camera that captures images in an electronic format (perfect for e-mailing or uploading pictures to a Web site). Digital cameras use computer memory instead of film and usually show you a small "thumbnail" version of your image immediately after shooting it.

Digital Imaging. Photography that is either a) done with a digital camera where the image is stored in computer memory rather than on film, or b) shot with a film-based camera and then scanned into a digital format.

Dioptic Adjuster. A feature on some cameras that allows those who wear eyeglasses to change the magification level of your viewfinder.

Disposable. A throwaway or single-use camera. Once you have taken all the pictures, you turn the whole camera in to the film-processing lab.

Exposed. A roll of film that has been shot.

Exposure. The amount of light that is allowed to hit the film. Balance is key here. Too much light results in overexposed, light

images; too little light results in underexposed, dark images. See chapter 3, "Better Photo Basics," for more on exposure.

Exposure Compensation. A function found on more expensive cameras that lets you slightly adjust exposure levels to compensate for circumstances that might trick the camera meter.

Exposure Meter. See Light Meter.

F-stop (or F-number). In the photo world, f-stops are the numbers that represent aperture. This combined with shutter speed, serves to expose each photo with the correct amount of light.

Fast Film. A film with a higher ISO number, such as 800 or 1600. Faster films are more appropriate in dimmer conditions or when you are trying to freeze action.

Fill Flash. When you use the flash during somewhat bright conditions to fill in shadows.

Film Leader. The end of the film that sticks out of the canister.

Film Speed. How sensitive a film is to light. Sensitive films react more quickly to light, and slow films react more slowly. A fast film, such as one with an ISO of 1600, will capture images more quickly and generally will provide better results in dim conditions. A film with an ISO 50 speed, on the other hand, is much slower, less sensitive, and works best in bright light or when combined with the use of a tripod.

Filter. A circular piece of glass that filters out certain kinds of light when you place it in front of your lens. Filters can be used to wash an entire scene in a certain tone, correct bad lighting conditions, make skies brighter, and more. Also, in the world of digital imaging, filters are software functions that can be used to make an image look softer, sharper, like it was shot through a particular photographic filter, and much more—all at the touch of a button.

Fixed Lens. Also called fixed focal-length lens. A lens that is permanently wide-angle, telephoto, or something in between; it does not allow you to zoom in or out.

Flare. Stray beams of light shining into the lens and onto the picture.

Flash. A function or accessory that allows you to provide additional, artificial light to a scene.

Flash Meter. A special kind of handheld light meter used to measure flash output in studio settings.

Focal Plane. The point in your photo that is in focus, along with everything else at that same distance from your camera.

Focus. The process where you make the image sharp.

Focus-Free. Fancy term for cameras that have no focusing mechanism. Focus-free disposable cameras, for example, are preset to get sharp pictures as long as the subjects are within a certain range of distances from the camera.

Focal Length. A way of measuring the magnifying power of a lens. A 50mm lens has a focal length of 50mm and sees things at roughly the same size as the unaided human eye sees them. A 400mm telephoto focal length is like looking through a pair of binoculars; things far away are greatly magnified. A 20mm wide-angle lens allows you to squeeze in an expansive vista.

Focus-Ready Lamp (or Focus-OK lamp). A little light, usually in the viewfinder, that tells you when the camera thinks it has achieved sharp focus.

Forgiving. Nothing biblical here. In photography, this refers to a film that is easier to shoot within its range of acceptable limits. Color negative films are generally more forgiving than slides. Thus beginners will likely get more good pictures with color negatives than with slides.

Form. A shape with three-dimensional depth.

Formal. Connotes a more traditional, staged portrait (in which the subject is usually dressed up a bit).

Format. Refers to the size of the film you use, such as 35mm format, APS format, and medium format.

Frame. Although this usually refers to one picture on a roll of film, it can also be used to describe the view you see through your camera's viewfinder. Also, framing can refer to a compositional trick where you look "through" something, such as tree branches or a window, and include them along the edges of your picture. And, of course, a frame is also something into which you place your picture before hanging it on the wall.

Frontlighting (Frontlit). When the sun is behind you and therefore lighting your subject from the front.

Glare. When light reflects off of a reflective surface (such as glass or a mirror) and back into the lens.

Glossy. The shiny, as opposed to matte (dull) finish on prints. A glossy finish seems to accentuate the nice, bright colors in your print (and the prints are much easier to scan on a computer), but glossy prints also show fingerprints more than matte prints do.

Grain. A picture in which you can see the tiny, microscopic particles in the film. A grainy picture looks somewhat fuzzy and the colors are dull. This is a common side effect of using fast films and enlarging photos to an extreme.

Highlights. The extremely bright points in a scene.

Hotlights. Studio lights that continuously illuminate a scene rather than burst the scene with a momentary flash of light, such as strobes do.

ISO. International Standards Organization. See Film Speed.

Index Print. One print on which appear tiny thumbnail versions of all the pictures on it.

Infinity Lock. A setting that allows you to lock your focus on what amounts to the farthest distance. This comes in handy when taking pictures through a window.

K. Kelvins; a measure of light temperatures.

LCD. Liquid Crystal Display. Refers to a monitor on a digital camera that allows you to review images immediately after shooting them.

LED. Light Emitter Diode. Refers to an electronic display that provides information, such as how many exposures you have left and whether your flash is on.

Lab. See Photo Lab.

Landscape. A picture of an outdoor scene, usually done with a somewhat wide-angle lens. Nature inspires the bulk of landscape photos, although sometimes people shoot cityscapes and seascapes, too. This term is also used to refer to images shot in a horizontal orientation, as opposed to vertical "portrait" images.

Light Meter. A device that measures the brightness in a scene to help the camera get the proper exposure. Most of the time

they are in your camera, but some photographers use special, handheld light meters.

Long Lens. See Telephoto Lens.

mm. Millimeter. A unit of measure used when referring to either a lens (a 100–400mm zoom lens) or to film formats (35mm film). Confusingly, though, millimeter is also used to specify filter sizes on some lenses. You may have a 50mm "normal" lens that accepts 52mm size filters. Common filter sizes include 48mm, 52mm, 58mm, 62mm, and 72mm. Common lens sizes include 28mm, 35mm, 50mm, 80mm, 100mm, and up.

Macro. Polo . . . No, really folks, macro actually means close-up photography. A macro mode or lens is great for taking pictures of flowers, bugs, stamps, and other tiny objects.

Manual Focus. When you dictate what to focus on in your scene, as opposed to letting the camera automatically do the focusing.

Matte. Matte (dull) prints, less shiny than glossy prints, are covered in a protective finish that hides fingerprints.

Midroll Rewind. A feature that allows you to rewind and remove the film before you are finished taking all the pictures.

Muddy. A term often used to describe underexposed images and pictures in which it is difficult to make out the subject. Such prints often look dull and brownish.

Negative. Film, both before and after developing. Think of a negative as the "original" and each photo print that comes from it as a "copy."

Normal. A normal lens "sees" things at about the same size or magnification level as the unaided human eye. Telephoto and wide-angle lenses, on the other hand, make things bigger or smaller than the human eye usually sees them.

Overexposure. When the film receives too much light and the picture looks dark (or light, if you are using slides).

P. See Program Mode.

Panorama. A very long, thin picture. This format is often used to capture panoramic vistas, such as that of an expansive landscape. Some digital software programs allow you to "stitch" multiple pictures together to create one seamless panoramic image.

Parallax. A problem in which the camera is too close to the subject and the viewfinder no longer accurately represents the scene that will be photographed.

Pattern. A graphic element repeated in a logical and orderly way.

Perspective. The way lines converge as they stretch farther away. Also, the way objects in your photo relate to one another in size.

Photo Lab (or Photofinishing Lab). The place you go to get your film developed.

Point and Shoot. A basic, automatic camera. Point and shoots are usually simple, inexpensive, compact, and easy to operate.

Point of View. The place and position from which you shoot.

Polarizer. A filter you can use to make skies deep blue and clouds ultra white.

Polaroid. A brand of instant picture (or the camera used to take it). Polaroids use a special kind of film that includes all the photofinishing chemicals within each picture and, therefore, requires no trips to the photo lab.

Polaroid Back. A special accessory that can be attached to the back of some cameras and is used to preview your final image. By giving you an instant Polaroid picture, it helps you determine if your exposure time is correct.

Polaroid Transfer. A copy of a slide that involves either pressing the Polaroid chemicals onto paper or cooking the emulsion off a Polaroid and applying it to a new surface. See chapter 7 for more information.

Portrait. A picture of a person or group of people. Also refers to pictures taken in a vertical orientation, when you turn your camera on end before shooting the picture (as opposed to horizontal, or landscape, orientation, for which you leave the camera flat).

Preflash. When the camera's flash emits a burst of light before actually taking the picture; usually used as an attempt to reduce red-eye.

Prefocusing. See AF Lock.

Program Mode. On some cameras, this represents the mode that automatically calculates both aperture and shutter speed for you. Most point and shoots offer no other options than this mode.

QD. Quartz Date. A function that allows you to print the date on each picture.

Red-Eye. When a subject's eyes reflect a red glare and look slightly demonic in a printed photograph. See chapter 6, "Troubleshooting," for a few ways to deal with this problem.

Royalty Free. Not a complimentary pass to see the British monarchy! Type of stock photography for which the buyer pays only once for all future use of the image. With other kinds of stock sales, buyers pay a fee each time they use the photo.

Rule of Thirds. Trick used to compose balanced photographs. See the section on composition in chapter 3.

S. See Shutter Mode.

SLR. Although car fans might think of an E6 Mercedes Benz 300 Super Light Racer (SLR), in this case, they would be wrong. In the photography world, SLR stands for Single Lens Reflex, a kind of camera that allows you to use interchangeable lenses. SLRs feature sophisticated focus, exposure, and flash systems. Also, users of the SLR look through the lens itself to see the scene rather than through a separate window known as the viewfinder.

Scanner. A device used to scan a photo, transforming it from a print, negative, or slide into a digital computer file.

Selective Focusing. The art of limiting depth of field so that only your subject is in sharp focus.

Self-Timer. A feature that delays the moment when the camera takes the picture. A self-timer allows you to get into the picture yourself or to shoot without actually moving the camera, thus avoiding the camera-shake problem.

Sensitive. Film description meaning that the film reacts more quickly to light than other films. For example, 1600 is a very sensitive film.

Sepia. A brownish-gold tone. A sepia print looks just like an extremely old photograph.

Shadows. The darker parts of a picture.

Shape. An area such as a circle, triangle, or rectangle.

Sharpness. When things look crisp and clear.

Short Lens. See Wide-Angle Lens.

Shutter. A mechanism that controls how much light is allowed to get into the camera.

Shutter Button. The button you press to take the picture.

Shutter Mode. Also called "shutter priority." On some cameras, this represents the mode that automatically calculates aperture after you specify the shutter speed that you would like to use. Most point and shoots do not offer this option.

Shutter Speed. How long the shutter is left open, or how long the camera takes to make the picture. Shutter speed is different from film speed but is directly related to it.

Single-Use Camera. See Disposable.

Slave. A device that triggers the camera to fire when a burst of light is detected, such as that from a flash or from lightning.

Slide. A small image encased in a cardboard frame that requires a projector (or small slide viewer) to display the image on a screen. Publishers love slides; friends and relatives will typically groan if you invite them to sit through 1,001 slides of your adventures in Orlando, Florida.

Slow Film. Opposite of fast film. Slow films generally produce brighter, less grainy pictures but can be more difficult to shoot, especially in low-light situations. Examples include ISO 50 and ISO 100 speeds.

Soft. Refers to photographs that are slightly blurry and out of focus. Can also refer to a diffused, gentle kind of light like that of a bright, overcast day.

Spotting. Dabbing a light amount of paint on dust spots, hairs, scratches, and other imperfections in a print.

Still-Life. A traditional shot of an inanimate object that is usually set up in a studio, against a plain background, and using controlled lighting. Common subjects for still-life photos include fruit, a bouquet of flowers in a vase, and products a company is advertising.

Stock. A collection of photographs available for purchase or licensing. Usually, these photos cost much less than fine art photographs and are used for advertisements in magazines and the like.

Strobe. A studio light that, much like the flash on your camera, momentarily floods the scene with light.

Subject. What you are taking a picture of.

TV. Stands for "time value." Especially on 35mm SLR cameras, this if often used to indicate a shutter priority mode. See Shutter Mode.

Telephoto Lens. A lens that magnifies your subject, enabling you to shoot subjects that are very far away, usually 80mm or above.

Throwaway. See Disposable.

Thumbnail. A tiny version of a digital picture that uses a fraction of the computer memory that a full-size image might use.

Transparencies. Slides. Also called "chrome" or "positives."

Tripod. Wise photographers often attach their camera to this three-legged stand to keep the camera steady while taking a picture.

UV. Ultra Violet. A kind of filter that essentially does nothing to change the look of your picture. It does, however, keep your lens from getting scratched.

Underexposure. When the film does not receive enough light and the picture looks light, muddy, or obscured if you are shooting with print film and dark if you are using slides.

Undeveloped. A roll of film that has not yet been processed by a photofinishing lab.

Unexposed. A roll of film that has not yet been shot.

Viewfinder. Fancy name for the little window in the camera you look through when you take a picture.

Viewpoint. See Point of View.

Wide-Angle Lens. A lens that gives you a wide, expansive view of your scene. Because more of your scene is squeezed into the picture, things look smaller through such a lens than they do in real life.

WYSIWYG (pronounced "Wizzy-wig"). What You See Is What You Get. Beginners are often surprised that point and shoot cameras show only an approximation of the image being captured, often causing novice photographers to miss part of their subject. SLR cameras, on the other hand, lets the photographer see almost exactly what the film will record, giving a much more accurate idea of how the final print will look. Thus, with SLR cameras, what you see is what you get.

Zoom. A zoom lens provides more flexibility by allowing you to easily change the amount of magnification just before you shoot. You can either *zoom in* to make faraway things appear closer or *zoom out* to make more fit into the picture. On point and shoot cameras, they are usually electronic and controlled by a toggle on the camera itself. On more expensive cameras, you move through the range of focal lengths by twisting the lens or pulling part of it away from the camera.

Resources

The Ultimate One-Stop Shop (By Yours Truly)

BetterPhoto.com Articles, photo contests, buyer's guides, tips, online courses, photo workshops, galleries, photo critiques, news, and Q&A, free for your viewing pleasure: http://www.betterphoto.com

Best Books for Beginning Photographers

Learning to See Creatively by Bryan Peterson. Inspiring and eye-opening guide on composition, design, lighting, and more.

Understanding Exposure by Bryan Peterson. Essential primer on aperture, shutter speed, depth of field, and other important concepts.

Starting Photography by Michael Langford. Wonderful first book in a series of comprehensive books for serious hobbyists.

How to Take Great Photographs with Any Camera by Jerry Hughes.

National Geographic Photography Field Guide by Peter Burian and Robert Caputo.

Photographing the World Around You: A Visual Design Workshop by Freeman Patterson.

Creative Techniques for Photographing Children by Vik Orenstein. Fun and helpful advice for those interested in getting unique pictures of children.

A Guide to Travel Writing and Photography by Ann and Carl Purcell. Practical guide for travelers who consider trying to make a little money with their camera.

Closeups in Nature by John Shaw. Inspiring photos with great writing.

A Short Course in Choosing & Using A Digital Camera by Denny Curtin. Great primer on digital imaging.

Books for Fun and Inspiration

Eye to Eye: Intimate Encounters with the Animal World by Frans Lanting.

Intimations of Paradise by Christopher Burkett.

Chased By the Light by Jim Brandenburg.

Examples: The Making of 40 Photographs by Ansel Adams.

American Photography: A Century of Images PBS series and companion book that offers a fascinating history lesson, jam-packed with fun stories and trivia.

A Little Light Reading: Best Magazines

Outdoor Photographer This fun magazine is always a sure bet for photographers interested in nature and wildlife.

Peterson's Photographic Jam-packed publication full of great reviews, articles, and tips.

PC Photo Sister publication from the makers of Outdoor Photographer, filled with lots of excellent articles on digital imaging.

Developing and Hand-Coloring Black and White Photos

Handcolor.com http://www.handcolor.com/

Chris Groenhout's Photography Home Page http://www.geocities.com/SoHo/Nook/4792/

More Info on Scrapbooking and Making Polaroid Transfers

Creative Memories http://www.creativememories.com/

CreativeScrapbooking.com
http://www.creativescrapbooking.com

ScrapLink.com http://www.scraplink.com/

Polaroid Transfers: A Complete Visual Guide to Creating Image and Emulsion Transfers by Kathleen Thormod Carr. http://www .kathleencarr.com

Polaroid's How-To on Transfers http://www.polaroidwork.com

For a Few Laughs

Twenty Things You Can Do to Ruin Good Pictures by Shad Sluiter. http://www.naturephotogallery.com/howto/bad_pics.htm

Hard to Find but Worth the Search

Understanding Exposure CD-ROM multimedia version of the excellent book.

Learning to See Creatively CD-ROM multimedia version of the excellent book.

Canon Photography Workshop CD-ROM featuring great interactive workshops.

Best Places to Buy Cameras

Your local pro camera shop If you can afford the higher prices, you'll likely get the most handholding if you shop locally.

Amazon.com Cameras Click on the "Camera & Photo" link on their home page: http://www.amazon.com

Cameraworld of Oregon http://www.cameraworld.com

B&H Photo http://www.bhphotovideo.com

Mail-Order Survey A gold mine of honest evaluations about various resellers. Browse this survey before buying from an unfamiliar camera store: http://www.cmpsolv.com/los/pmos.shtml

Best Places to Get Your Film Developed

A good mini-lab near you

A & I This online developer is especially good for slides: http://www.aandi.com

Ofoto Online photo printer: http://www.ofoto.com

Index